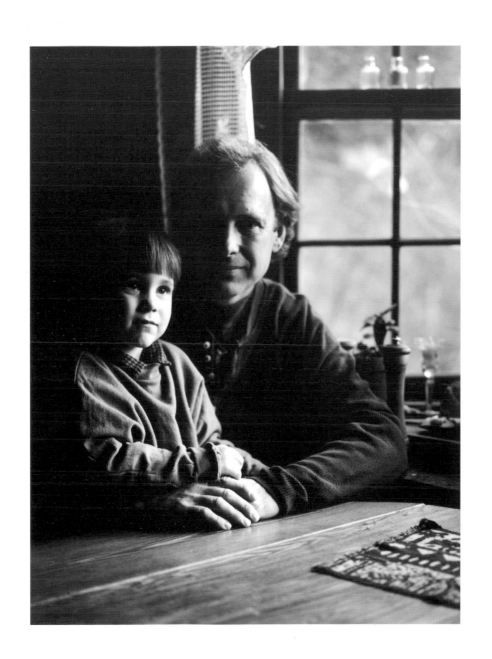

father&son

The Bond

Photography by Bill Hanson
A collection of photographs and essays

Library of Congress Catalog Number: 95-83314

ISBN 1-880092-19-0

Printed in Hong Kong

Edited by Paula Stout
Designed by Trevor Lemoine

Digital imaging and scanning by CMYK Pre-Press
All photography shot with a Mamiya 645 Pro camera and Kodak TMAX 100 film

12 11 10 9 8 7 6 5 4 3 2

Bright Books
P.O. Box 50335
Austin, Texas 78763-0335
512-499-4164
Fax 512-477-9975

BRIGHT
BOOKS

For my father and my son

Contents

Acknowledgments

My thanks to a whole host of people for making this book possible.

- To the father and son teams, much gratitude for your willingness to be in the book and allowing the world a glimpse into your lives.
- Paula Stout and her words, words, words—thanks for helping me pick the right ones,
- Trevor Lemoine, aka the Macintosh Guru, only a phone call away,
- Daniel Ankele for helping me keep things in focus,
- Jan Pearce, "You're going where? Sure, I can get you there."
- Paige Brethower for her sustaining support and camera flash expertise.
- To all the people who helped with the logistics of the shoots, production of the book and friends who believed in the book and encouraged me to go for it: Rebecca Austin, Beth Borgman, Michael Cullen, Randy & Tandy Dryer, Steve Ford, Shelly Grahm, Marlene Hillen, Andro Kotula, Don Levy, Laurie Lieser (The conference call queen), Rita Maranda, Richard Martin, Jennifer Nelson, Annee Reed, Chris Shanks, Karan Shirk, Robert Stein, Kevin Tedesco and Carey Windler.
- And most, especially, thanks to my father, who made me a son; and my son, who made me a father.

The Candlelighter Childhood Cancer Foundation's mission is to educate, support and advocate for families of children with cancer, survivors of childhood cancer and the professionals who care for them. Because of the photographer's admiration for the good works of the organization, a portion of the proceeds from this book will go to help Candlelighters.

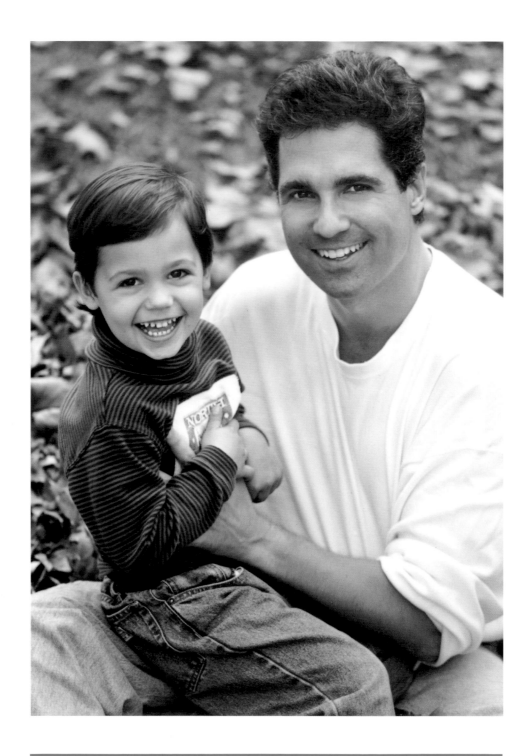

Bill Hanson & son Miles

Photographer

The Bond

My father was the finest man who ever lived. William Andrew Hanson II was my hero. He was John Wayne, Audie Murphy and Joe DiMaggio all rolled into one. He was equal parts friend, mentor and confidant. We spoke without words and loved without barriers. Dad grew up without a father. His father died when Dad was only ten years old. Life must have been lonely for a boy losing his father at such a young age, but Dad never wallowed in self-pity. He was independent and strong: a stubborn individualist. I don't know who taught him how to be a father; but, I can tell you this, he learned the lessons well.

It wasn't easy for my parents to raise three boys. As I grew older it was obvious that money wasn't plentiful, but Dad never lost his enthusiasm for living. Even our simplest conversations were painted with smiles. "Dad," I would say, about to ask to borrow his hammer, or some other mundane question, and he would look up from his work and say in his unique way, "Yessiree, Bob-tailed, Buffalo Bill, Leroy Hanson the Third."

He had a real way with words and instilled in me an appreciation and knowledge for language. If you asked him the meaning of a word, he could tell you the complete etymology of it. Sometimes lessons came when I least expected them. In high school, I brought a date home to meet my dad. Trying to impress her, or just being a teenager, I was sneering and being insulting to just about everyone in the room. Dad finally said, "Bill, I want you to go over to my dictionary and tell me what the word 'sarcasm' means."

He said it in such a commanding tone, I didn't resist. I flipped open the page and found the literal meaning—to rip flesh. In one single moment he taught me the power of words. I haven't forgotten it.

The day he died was the hardest day of my life. My world had hinged on him. No person had loved me the way he did: a love so real and unconditional. I began to appreciate how lonely he must have been when his own father died. Without Dad, I thought the hope in me had also died. Our friendship spoke to my soul and now the conversation was silent.

Becoming a father myself wasn't high on my list of things to do. I had a sense that someday it would happen, but not in the immediate future. Dirty diapers and responsibilities were not my idea of a good time. Almost a decade after my father died, an infant changed my mind. His name is Miles Christopher Hanson.

When I think about my life today, I see it as *before child* and *after child*. Becoming a single father means there are new challenges for me. I must be prepared to meet obstacles I never knew existed and keep one step ahead of my growing boy's needs.

Unfortunately, there was no school degree to prepare me for fatherhood. I went to the book-stores, scoured the shelves for something that would give me a recipe for being a good father.

Nothing. Here I was, endeavoring to take on the biggest commitment of my life and I had no lines, no textbook, no videos to tell me what to do. It was a job with no description. People would say to me, "just love him." Loving was the easy part. Being a father was not.

I was terrified the first time I held this small, pink, wrinkled bundle in my arms, the first time I gave him a bath, the first time we were alone together. All I could do was remember my own childhood and realize that my father had been my world. It was the best advice I found. Slowly I began to realize that I had, too, become Miles' world. I just started taking my cues from him and we did okay together. In fact, now we are inseparable.

If I am mowing the lawn, Miles mows the lawn also. If I am reading the paper, Miles reads the paper. If I am thirsty, so is Miles. Amazing, but he is imitating my steps as I once copied my own father's. Here is the cycle of life. We learn from our fathers, so we can teach our children.

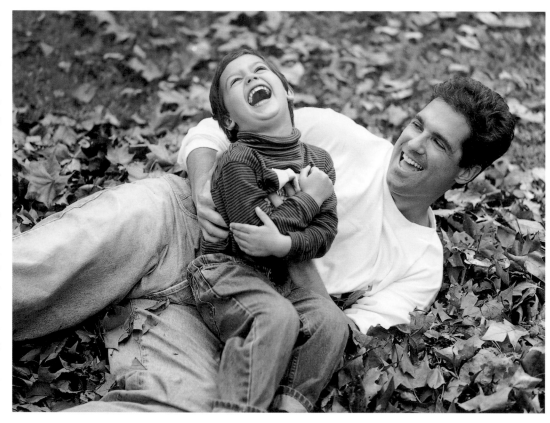

Miles taught me that the hope my father had in abundance did not die with him. When I look at Miles, I know what my father saw in me. Hope for a better future. I wish there was a way to share with my father his precious grandson. Fate didn't see it that way. My mother married again and now both Miles and I benefit from a caring step-father. We have developed a father and son bond based on love, mutual admiration and respect. He has been there for me as father, friend and counselor. He has also taught me that fathers and sons don't necessarily have to share flesh and bones. A father is someone who is willing to claim a son as his own and take the responsibility of that relationship. I am fortunate to have his influence in my life.

Being a father (parent) is—and let's face it—a pretty thankless job. In today's media the only fathers we see are the "dead-beat" dads. Where are the millions of men who toil day after day, sacrificing their own needs in order to fulfill the needs of their family? The men are out there, but there are no rewards. Think about it, when the cameras pan the sidelines at a sporting event, do you hear "Hi, Dad"? No. Moms get all the credit.

I consider the relationship between mother and child equally significant. In fact, Miles has a great relationship with his mother as I do with mine. The book is a celebration of parenting; specifically the relationship between father and son. As fathers, old expectations were to protect, discipline and provide. Today, society expects and needs men to be more involved, but how?

Each father and son team in this book has found common ground in their relationship. Some fathers are in the wonderment phase—seeing the world through the eyes of their growing sons. Other fathers are watching their sons cope with the demons of today. One or two fathers are re-discovering their sons. Some sons are fatherless and some fathers are sonless. There are fathers who have watched their sons combat a fatal disease, others who have watched their sons grow into successful businessmen. Some of the fathers have been primary care givers to their sons, while others have felt the pain of seeing their sons grow up in a distant city because of divorce. One of the fathers talks of sharing the moment of winning a world championship title with his son, and another father writes of reading Goose Bumps to his sons each evening. Fathers talk about newborns entering the world and about coaching little league, of sons marrying and having their own sons, and of the passing of tradition. Each has taught by example and each has loved unconditionally.

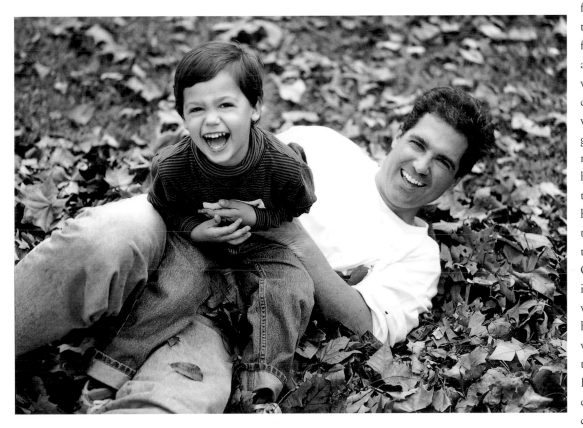

On the following pages you will see dozens of men who are doing their best for their sons. You'll also see sons who are making their fathers' proud. Not because they are presidents, star athletes, millionaires or celebrities, but because at one point in history a man had a son. And that son had a father who became his whole world. They learned from each other, laughed with each other, argued with each other and loved. The bond between fathers and sons is unbreakable. It can be celebrated, cursed, strained, ridiculed and honored, it cannot, however, be broken.

Cory Wilson & son Cameron

Musician

Cory Wilson: Over the sand and the worlds beyond, the parent and child wander alone, bareheaded, barefoot. A man, yet by these prints, a little boy again. Seeing our path, who is the father and who is the son? Who is the teacher and who is the student?

The truth is that Cameron and I learn from each other. Through him I get to relive my childhood. His love is my healing. The part of me without a dad is consoled. I not only get to be the parent, I get to be the kid. We go through growing pains together, and—I'll let you in on a secret—they don't improve with age.

As a father, my job is to help Cameron grow into adulthood. Hopefully, through my actions he learns what is right and wrong. Through my teachings, he will find his own philosophy. And, if I do my job right, Cameron will discover how to love. Daily, I witness my son building his character and becoming his own person.

The hardest part and the best part—crazy isn't it?—is knowing that soon he will no longer be my little boy, but he will be his own person. He will be laughing, loving and sharing his life with his own children. And, someday, he will be walking on the beach and holding his son's hand. My grandson will try his best to keep up, matching his smaller steps to his father's. Cameron will say, "Your grandpa and I used to walk like this." Then, they'll walk a little closer and the sea will carry their footprints away.

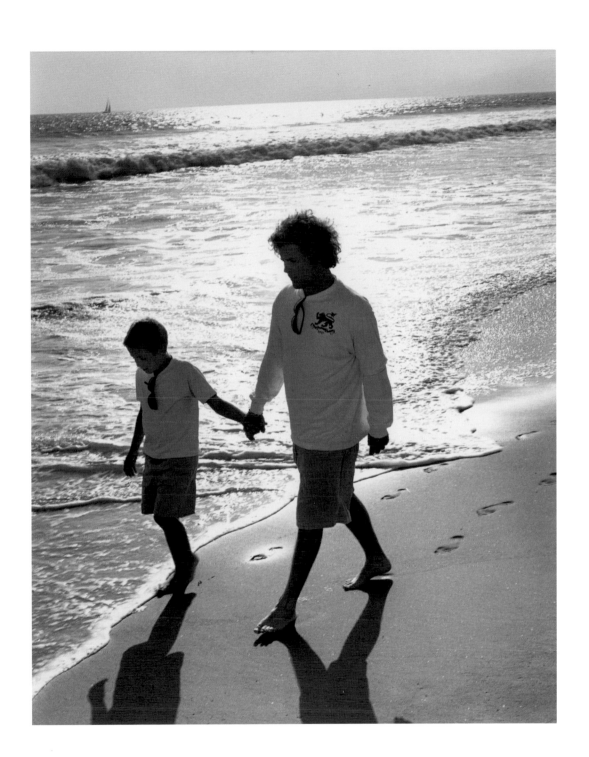

Joe Sutton & sons Michael & Robby

Publicist / Actor / Actor

Michael and Robby.
Those two words might as well be paradise and heaven.
From the moment both of them entered my life,
I knew I had done what God sent me to do.
Everything else is just a bonus.
We talk without speaking, support without request,
listen to each other with our hearts.
They have taught me more about life
than I could have ever taught them.
My only prayer is that they love and respect me
as much as I love and respect them.

—Joe Sutton

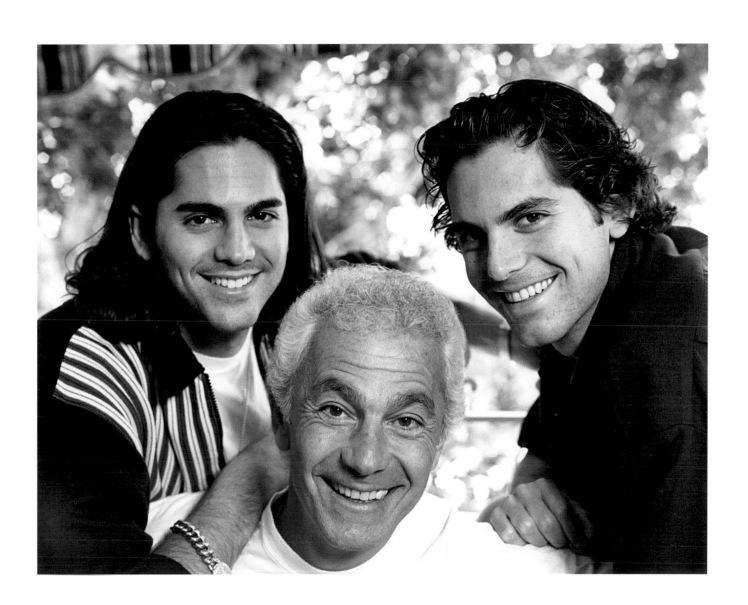

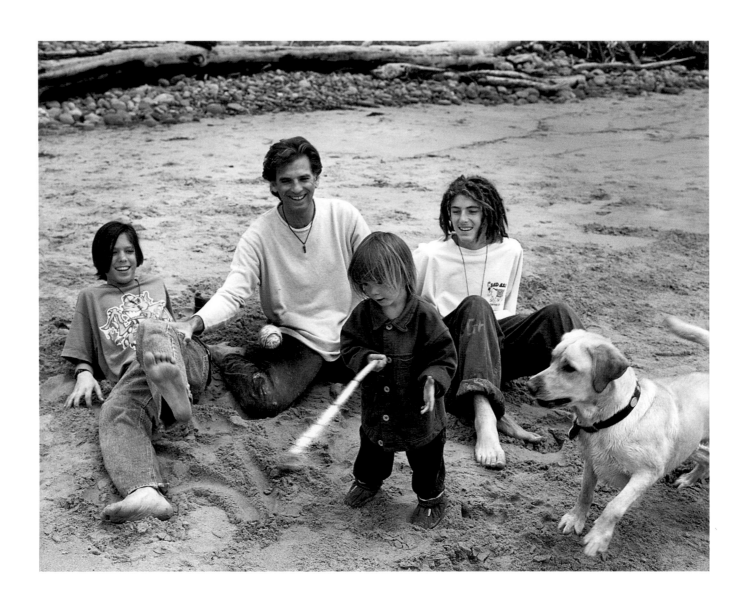

Kenny Loggins & sons Crosby, Cody & Luke

Singer and Songwriter

I n my voice
In my smile
In the eyes of my eldest child
You appear ever near in my life
In a dream
I am now
Standing still in My Father's House
And I try another time to walk away

I learned of music and laughter
From the child that you hid in your eyes
It's his song I sing
Now who will sing for me?

All my life a voice inside
Has whispered, "Set me free"
All this time
Has it been
You
Or Me?

I wait for someone to save me
Just like you did all your life
Will I find my home
Or die alone like you?

—My Father's House
(Kenny Loggins & Will Ackerman)

9

Kenny Loggins: For the Love of my Children

Are we ever really free from the gravitational pull of the moon? Can a child ever stop loving his father or needing his father's love? I don't think so. As I see it, this is simply "emotional physics."

I guess that's the good news and the bad news. We crave the love and acceptance of our fathers yet many of us may never truly obtain it this time around. Are we then destined to search for it in the eyes of lovers and friends the rest of our lives, like Diogenes in search of the honest man? And is this yearning just a hole no one else can ever really fill?

I now believe that somehow as I parent my children I begin to heal the wounds of my own childhood. Slowly, often painfully, I kneel in the dark, opening boxes of long-hidden memories and feelings I'd years ago assumed were better left unexamined, undisclosed even to myself, unchangeable and ultimately unnecessary.

There in the dark, but for the love of my children, they'd have stayed unearthed like so many dinosaur bones. "Who needs 'em?" I figured. "Who needs the pain?"

But the baby is born, and as those dinosaurs come screaming out into the light, trampling my well-placed life, trashing my carefully planted rows of plans, "You do!" is the only inevitable, loving and painful sound I hear within his birth-cry.

But I do have a choice... and yet I don't.

History wants to repeat itself, such is its vanity, so Crosby, my fourteen-year-old, plays guitar and writes his own songs. ("Hell, Dad doesn't work for a living, why should I?") He is my "outer face," and as such, presents himself to the world as the confident and streetwise performer I thought I wanted to be back then. Being fourteen he pulls me in and pushes me away all at the same time. He needs a male community to civilize him, but unfortunately in our world no such society seems to exist. So we dance alone.

To the south, in Los Angeles, my thirteen-year-old, Cody, now lives with his mother. Four or five days a month is barely enough to get to know him, or him me. This distance, physical and emotional, is the only great pain in my life. This constant longing is the kind people must simply shut-off to, or somehow learn to exist with, and is my biggest struggle.

Cody is my "inner face", and I know him as I know my secret heart. (Julia and I refer to him as "the heart with feet.") He is the "Karate-poet-comedian," stoic and intensely moral, an archetype of a kind of self-burning hero. Our time is yet to come. I know it will be tough, yet I long for it.

And lying next to me is baby Lukas Alushka. Almost two years old, he is a man on a mission. His name means Spirit Warrior, and sure, I know I've saddled him with my own lofty vision, but it is also my prayer for him.

Luke is the Lancelot to my Guinivere. He fire-walks with us, always reminding me to be joyful in the storm, "Life is bliss, isn't it?" He sighs. He is the third son of the third son of a third son. No legacy there, eh? No wonder I feel a sense of urgency to awake and walk consciously into my dream.

For the love of my children I must again challenge the unknown, my hidden self. I will turn to face my own storm and make peace with my hurricane to keep from passing that storm on to my sons.

But I don't mean to say that my father was a bad guy who only screwed me up somehow. Please don't misunderstand me. He was a great guy. Gentle, loving and patient. He taught me how to play baseball, basketball (we were killers in our neighborhood at two-on-two), track (he was a champion hurdler in high-school), touch football, golf, as well as how to listen and make friends, how to notice the things others do, how to be a leader.

For the love of my father I became a performer and unknowingly fulfilled his unfulfilled dreams of the stage. But, dad passed on his demons too. I think a child believes that the act that truly proves and earns love is to become that parent. And so we take on all dad's emotional values and beliefs as well as his fast-ball and jump-shot. This becomes our heritage.

Yet, as I gain awareness of what's his and what's mine, I discover who's really here in this body. Slowly but surely I send this message of freedom to my own children: "I love you. You are free to be you, wherever that takes us."

Perhaps their father's ultimate legacy will be remembered as this:

> You are never trapped.
> You have the power to change your life... to make it better.
> Setting yourself free is your greatest tribute to me.

For the love of my children, I can and will change.

Don Levy & son Niko

New Media Entrepreneur

Don Levy: Yesterday you jolted me with a powerful emotional moment. Why? At the time you were reveling in the gusto of laughter and play, totally into discovering new things around you. You were running around in your carefree way. I had this flash right then and there, of the moment I went deaf. I was the same age you are today, 17 months old. I cried. I was out of control. I realized now that at that moment my spontaneity of discovery, its joys and power ceased. You gave them back to me.

You have opened my eyes in a way I thought impossible. You have touched my heart in ways unimaginable. You have taught me things and shown me places I never knew existed. You are my teacher.

I have spent a lifetime of searching and wandering, wondering where all my feelings were. Oh, I know anger and fear and rushing through life as constant companions. Other emotions were but an intellectual exercise. All that changed on July 27, 1992, when the doctors put you in my arms; the dam burst wide and a wave of emotions washed through. We connected, we were heartbound. Every time you say "Daddy," I am under your spell.

Vernon Maxwell & son Vernon Jr.

Professional Basketball Player

Vernon Maxwell: When I first held my son in my arms, I was terrified. It was a struggle, a time in my life when nothing was quite secure. Here was this child, with my eyes, in my image, looking right back at me. He is totally dependent on me. It's scary, but a great feeling. He has put me on a pedestal and has made me his role model. I cherish that more than anything else.

In 1994 when the Houston Rockets were in the playoffs, Vernon Jr. was by my side. He knew everything I was going through—every pressure.

He understood.

He'd tell me, "Don't worry, Dad, you'll get the next one."

When we won the championship, he was there, right by my side. If it never happens again, he'll know how awesome those moments were.

Whether or not he chooses to play basketball, I want him to excel in school. Vernon, Jr. is a straight A student and as long as he has his books, I know he'll always have something to fall back on.

I want my son to be a strong black man and carry respect for himself and the people he meets. I want him to do his best—and that just about covers everything a father could really want.

David William DeFreest, II & III

Dairy Farmers

David DeFreest II: On a dairy farm there are chores, which have to be done every day, some are more pleasant than others. One of the most important, and less pleasant, is to remove the manure from the barn area. Years ago, my dad would load the manure by hand into a wheelbarrow. He'd dump it down a big hole where it would land in the spreader. He would drive the spreader out and distribute the manure over the field. I usually accompanied him, starting to ride on the fender of the tractor and ending up in his lap by the end of the route.

One extremely cold evening when I was seven years old, Dad told me I couldn't do the nightly chores with him. The night was crystal clear and the blistering wind blew hard from the north. He said that I needed to go back into the warm house.

I stayed in the shadows until Dad drove the tractor and spreader out of the yard. I waited until he was about a half a mile from the barn, where he always took a turn into the field. I stepped out of the shadows and he saw me. He smiled his crooked grin, and welcomed me aboard without words. I knew he wasn't going to be mad. There was a long period of silence as we drove across the field. We were almost done when a meteor sailed across the sky. The blue and orange tail, like a flame, burned across the sky. I haven't seen anything like it since.

When little David first tried to walk, I watched him fall countless times only to get up and perservere. I recognized the same determination from my childhood and my forefathers in him.

We only met 16 months ago, but I've known this boy all my life, my father knew him, too.

Chris Fields & son Ryan

Firefighter

Chris Fields: Sunday, December 6, 1992, 8:05 p.m.

The best day of my life. The day my son, Ryan Christopher, came into the world—all nine pounds of him. Watching the birth of Ryan was an indescribable feeling. I felt a lot of pride, excitement, happiness and some disbelief that I was actually becoming a father for this was the end of a long four year period of trying to be a parent.

The overwhelming wave of love when my little buddy was born left me speechless. I never knew I had this much love to give. He hits on every emotion, he makes me laugh, he makes me happy, he makes me angry and he sometimes breaks my heart because I know someday he won't be my little baby.

Wednesday, April 19, 1995, 9:02 a.m., Oklahoma City. The day America changed. I was on one of the first firetrucks arriving at the bombed Alfred P. Murrah Federal Building. The building was destroyed, the city devastated. People lost those nearest to their hearts in a blink of an eye. 169 victims— 19 of them children. Everyone who worked those tireless days walked around in a daze. We couldn't believe it had happened.

People ask me today if being there and seeing the destruction makes me love Ryan more. "No," is my immediate answer. There is no way I could love my son anymore or any harder than I do now. However, what has become more precious is the little things we used to take for granted. Every bath I give him, every book I read to him, every trip to the park is more precious than before and truly a gift from God.

To Daddy's Rhino, you are my life.

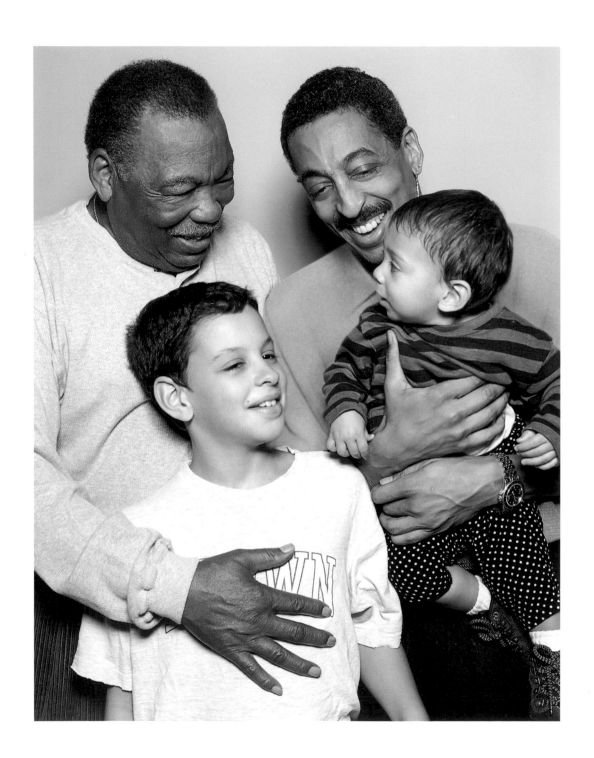

Maurice Hines & son Gregory & grandson Zachary & great-grandson Lucian

Full-time Grandfather / Performer

Gregory Hines: Maurice Hines, Sr. – Father – Daddy – Mentor – Teacher – Role Model Supreme. Daddy has always taught me by example. Watching him as I grew up and how he related to me, taught me how a man should relate to his son. On the great journey into Manhood, I watched him. Every nuance became my creed; every suggestion my code; every approval my joy.

When my children came, Daddy was there again. The delight on his face when he held Zachary for the first time. Wow! He must have beamed the same way at my infant face.

What you see in this photograph are four generations. Son, grandson, great-grandson. See how much happiness Daddy brings his grandchildren... well, what can I say? Look at him—you see it right there on his face... the love, the heart, the strength, the life, the father, the grampa, the Man.

Daniel Ankele & son Matthew

Photographer

June 18, 1989: Father's Day.
No greater gift could have been bestowed to me
than my son Matthew.
Matthew which means "Gift of God" in Hebrew,
was the most appropriate name to give him.
Told by an emergency physician,
my wife was lead to believe
that she miscarried our son in the first trimester.
It was not until the second trimester
that we found out the embryo was still viable.
At the time of my son's birth, I was also reborn.
I could no longer think only of myself,
for here was this perfect being that required
so much of my love and attention.
His importance was placed above my own,
and if need be, I would give my life for him
without a second thought.

–Daniel Ankele

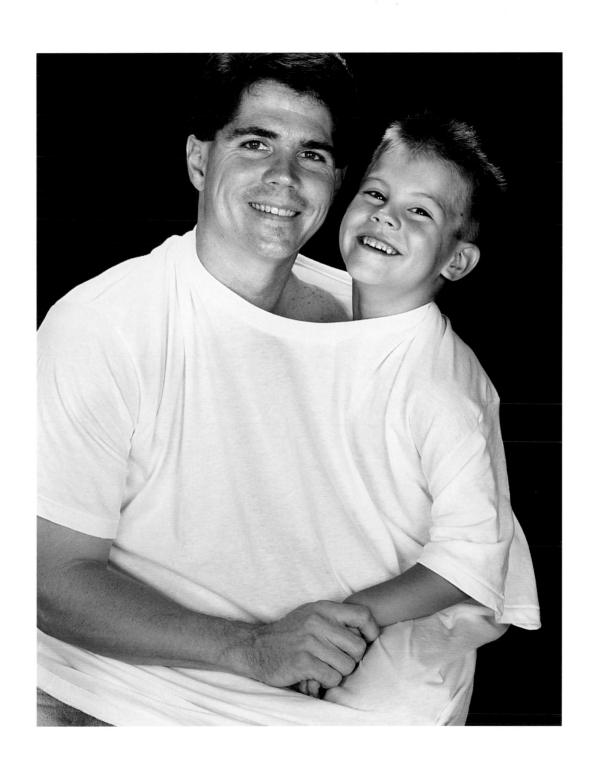

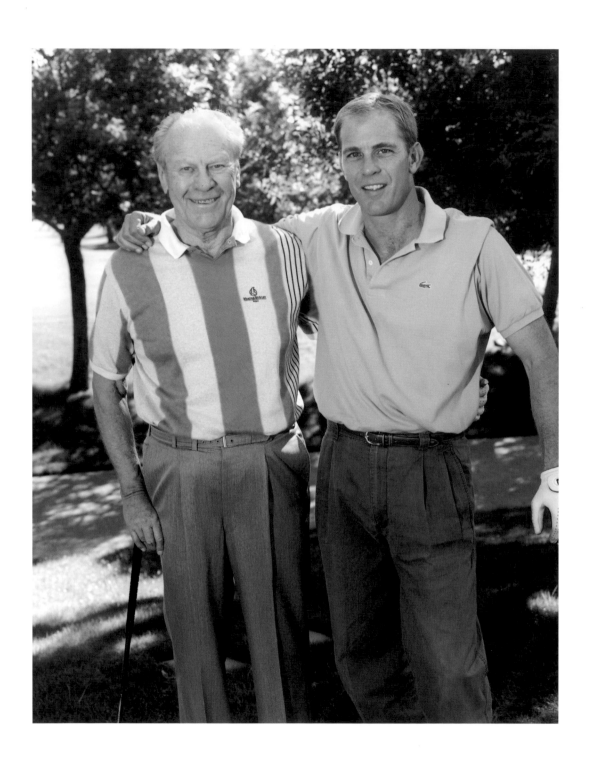

Gerald Ford & son Steve

38th President of the United States / Actor

Gerald Ford: As a father, one of the special blessings of becoming a senior citizen is the expansion and strengthening of relationships with one's children. Steve and I, in the last few years, have enjoyed a very special mutual feeling for each other. A similar relationship developed with our other children, Mike, Jack and Susan. With Steve, golf became the catalyst.

I have loved the game for most of my life. Steve became addicted 3 years ago. Our affection for golf brought us together like never before. I've been thrilled to see Steve's progress from a rough beginner to a darn-fine shot-maker.

Most of all, I've learned to cherish the camaraderie of riding in a golf cart with him for 18 holes. We encourage each other shot by shot, but there is ample time for conversation about Steve's plans and what his mother and I may be doing in the future.

This newly developed understanding and affection makes up for the years when Steve was young (8 to 21 years old) and I was overly committed to my job as a congressman, Republican House leader, vice president and president. In retrospect, I was not a father who could or did spend the kind of regular time with our children. Regrettably, the heavy job demands intruded all too often.

It wasn't all bad, because I knew how important it was for a father to have a special family togetherness with each child as they grew up. We did have many wonderful Christmas holiday ski vacations at Boyne Mountain and Vail.

I did share a lot of skiing with Steve who soon surpassed me on the slopes. Skiing, like golf, gave us the opportunity—while riding the lifts—to discuss his hopes and aspirations for the future.

I will always treasure a trip that Steve and I made to Alaska in the summer of 1968 when Steve was 12. I had several political speeches in Juneau and Ketchikan. Steve accompanied me from Washington. While I was campaigning, he spent a few days in Alaska's wilderness with a hunting and fishing guide family. We joined up for some great salmon fishing before returning home. Steve believes his experience was a unique gift, because he fell in love with the wilderness. Alaska opened his eyes to the inspiring beauty of nature.

As I recall these past experiences with Steve, I realize how meaningful they were to me, but I also recognize these incidents did not occur often enough. That's why our get-togethers now are very special. We are making up for lost time.

When Steve calls to say he is coming to Rancho Mirage or Vail for a weekend of golf, it means another strengthening of our friendship. In a long weekend we have great golf, but the evenings together with his mother and me are super special. As parents, we cherish Steve's desire to be with us. We are so fortunate to have this relationship and the opportunities to share it forever with each other.

Steve Ford: This is a great time in my life, having Dad healthy and able to build on our father/son relationship. The time spent with Dad today is precious because for so many years when we were kids he was away from home serving his country as a congressman, vice president and eventually president of the United States.

I understand so much more today how important it is for fathers to be home. No doubt it was hard on us kids. There was some guilt involved when complaining about his absence since so much of his work on Capitol Hill and in the White House helped change people's lives for the better all over the world. Instead of complaining, I kept those feelings inside my little body. That still didn't stop my desire to want my dad home more.

Where we were truly lucky, was the fact that when dad was home he focused on his family. I remember afternoons with Dad in our backyard teaching me how to snap a football so that I could make the football team and be a center just like he was at the University of Michigan. Dad taught all us kids how to swim and snow ski when we were four and five years old. He loved sharing sports with his family. Even today, thirty years later, our whole family plus grandkids keep up the tradition Dad started and ski together at Christmas.

About three years ago I felt this strong desire to increase the time spent with my dad. I can't explain that feeling, it just seemed to occur naturally like the seasons. I just wanted to hear his stories and tell him mine in a different light now that we are both older. I think a lot of young men and fathers feel this same desire and it is important to act it out.

My answer was golf. This is a game Dad loves and now we share the experience together, father and son. One of the true highlights of my life today is just spending four to five hours alone with him out on the golf course. We just talk and listen to each other catching up on time lost years ago. It's good for both of us. A little $2 skins game always adds to the moment.

I think I discover a little bit more of him in me every time we play, whether studying his reactions to a shot or just listening to his stories. Every son needs to understand where he came from, and my father possesses one of those keys.

The best feeling might just be sensing his excitement on the phone when I'm headed down to Palm Springs to play golf with him. That excitement in his voice makes the little kid in me smile. Every son needs to know dad can't wait to see him. Thanks Dad. I love you.

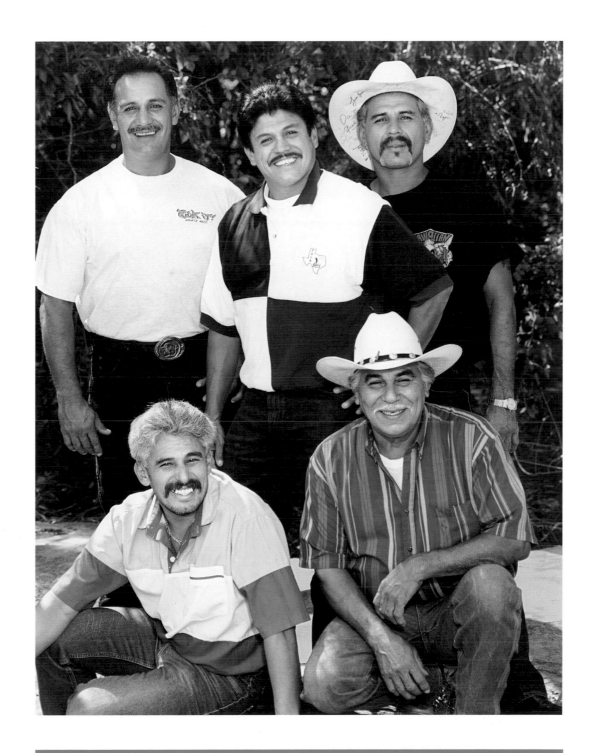

Vincente Sanchez & sons Anthony, Jim, Louis, & Eddy

Paint Company Owner / Telecommunication Specialist / Painter / Painter / Painter

George Schenck & son Willis

Baker

George Schenck: Willis—he is three—and I were coming home from taking his sister Hanna—she is eight—to school this morning. As we started up the hill over by Rupert Blair's place, Willis spontaneously and in no particular context to our conversation began listing things. I sat and listened to my son's repertoire:

I like trees, I like the sky, I like my mom
I like Hanna, I like rocks, I like my dad
I like the air, I like....

As he went on, I began to hear the chant as a child's poem, a poem from some hidden place in Willis. A place deep within his heart.

When he had finished, he looked over at me and smiled. I smiled back and we both laughed.

Hilltop Dads

Bill Innes and son Jim; Everett Musick and son Larry; Lee Petty (not pictured) and son Scott; Bill Simmons and son Bob; Omar Smith (deceased) and son Don, Durwood Thompson and son Woody

Two decades ago we decided to invite our dads on a weekend retreat. As young men in our mid-twenties, we were just getting started in our careers and in our families and we were finally at an age where we realized that our dads were pretty smart, after all. This weekend retreat would be an opportunity for us to ask questions of them. They, in turn, would share some of the knowledge and wisdom they had accumulated over the years.

Our great fear was that the dads would not feel comfortable with a group they did not know, and that after fifteen minutes we would be sitting around looking at each other with nothing to say. The reality was that they were flattered to have their sons looking to them for guidance and we could hardly shut them up. The weekend was a great success, a lot of fun and we decided to do it again a year later. That was in 1976, and in the summer of 1995 we had our twentieth meeting. Our topics in the first meeting included faith, family, finances and future—they still remain our guiding topics.

Together we have come through the death of one dad, the death of one mother, marriages, kids, divorce, career changes and other challenges. The support of the group, the wisdom of the dads and our common faith in Christ have made this 20-year journey much easier.

Don Smith: There were all sorts of unknowns that first weekend. Would the dads come? Would they get along with the other dads? Would they open up in front of strangers? Would they want to do it again next year? They did all of that and more.

I wanted to do this with my dad to make sure we enjoy the time we had on this earth together. And we did. Just before the sixth annual weekend, my father passed away. All the dads and sons from the weekend came to his funeral. For him and for me.

I've continued to meet with them every year and I have received a gift I hadn't anticipated. I now receive the collective wisdom and love of five other fathers.

I think of my dad almost every day. I often miss him terribly. I cry for him sometimes. You know, it is scary facing manhood without your father. But, I know that there are five dads who I can call on anytime and anyplace for wisdom and support that can only come from a man who has raised a son.

Paul Barrere & son Gabriel

Singer and Songwriter

Paul Barrere: From the moment Gabriel entered my life, and with each day, he fills my heart and soul with a glowing love. It was a cool evening, 20th of June, 1989 at about 11:30 p.m. when my wife, Pamela, and I left our house bound for the hospital. Nearly nine hours later, after a few scary moments, I saw my son for the first time. My heart was pounding and tears filled my eyes as I thanked God for this gift of gifts.

Six days later I was on a plane to Europe, Little Feat, my band, was in the middle of a tour. I was lucky that we had scheduled a three week break around the projected birth date so I would be home for the main event. Of course, Gabe held his entrance over for a week (he has a flair for the dramatic), so our initial time together was cut short. However, Pamela and Gabe joined me three weeks later in New York City for some rockin' & rollin' bus rides, and that m–m–m–good ol' hotel livin'.

That is how we started and over the next years Gabe and I forged a bond even though the band's touring schedule kept me busy and away from home. Finally for the last couple of years, my touring has a pattern that allows me more time at home. We are growing closer and closer as we see each other more. I watch as pre-school gives way to Kindergarten, and then onto the first grade. Oh, the wonder of learning. Now he can read me a bedtime story instead of the other way around. The joy of watching him play in his first T-ball little league game, that first hit, first catch, first throw. Pride fills me as we play catch together in the back yard, as my father—for whom Gabriel is named—had with me once so very long ago.

Yesterday I took Gabriel to school, as I often do. I can't describe what went through me as I watched him walk away into the school yard, a book-bag on his back, a little man on his own. What a wonderful, kind-hearted, gentle little soul he has become. The angels surely danced the day he was born.

Charlie Brown & son Lou

Photographer

Charlie Brown: Although he is only 15 months old, Lou knows things. Lou has been here before... he sits in "Louie Land," his play area, and reads books—mostly upside down—and talks to his stuffed animals ("moo"). He even plays mini-basketball with his mom, Rita, and older brother, Jesse. He actually won a game by hitting the last shot while clinging to the side of the Play-pen. And then there was the first time we took a "Tub" together... one of our first bonding experiences, lovely... till I found out he had pooped in the Tub out of sheer joy.

Actually, our first bonding experience came at birth. Rita had an extremely difficult pregnancy. When Lou was born, we almost lost his mom. She was in the operating room for over six hours, with ten doctors in attendance. As a result, upon delivery Lou was not placed on his mother's breast, but wrapped in a blanket and handed to me instead. And so, I became the first person he met on this Earth.

Lou was named after Rita's brother Lou, who died from Epilepsy at the young age of 29. They were very close, and as a result there is a lot of Lou in Lou... you can feel his presence as we hike through the woods on a summer's day. One day while crossing a beaver dam, we startled two beavers who quickly jumped into the water. Lou, who was sitting on my shoulders at the time, quickly called, "moo!" The beavers seemed to take comfort in the greeting. Lou knows things.

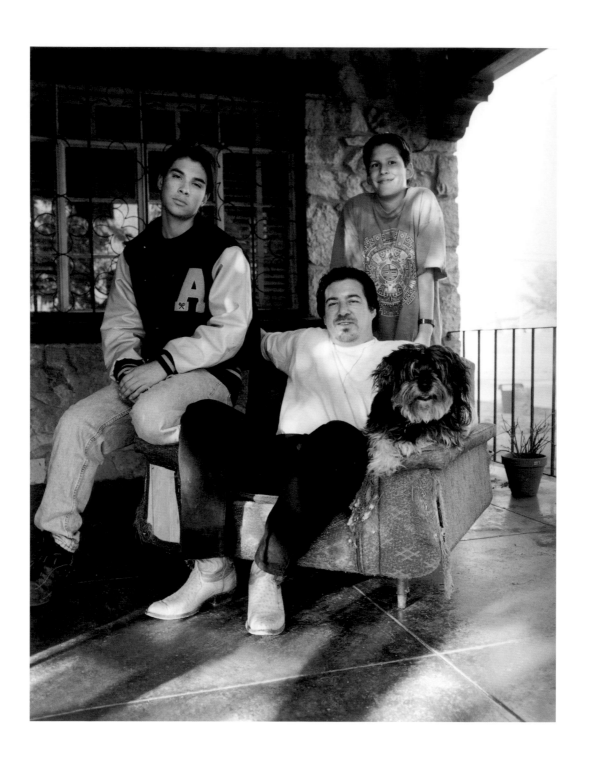

Dagoberto Gilb: Dear Antonio and Ricardo—Many people think hard about whether or not to have children. These are conscious people, usually better off, older, and they make a choice. Many don't think enough about having children. These are people not conscious enough, usually poor, usually way too young, who don't understand what choice they are making. I was between these worlds when each of you were born. And—you will both come to understand this too well, too soon—I would have said no, not now, not yet, but because of my love for your so beautiful mom, our love, I also would think yes, want yes, because I wanted to have babies with her. There was no plan, no preparation. When each of you were born, there was no bedroom to paint blue for you. In El Paso, on an apartment porch, I made a crib with a skilsaw for you, Toño, though you never slept in it once. In Los Angeles, we bought you a simple, inexpensive (though not for us) department store crib, Ric. You took daytime naps in it. At night, both of you slept against your mom and only near me. Someday, if not now, you'll remember the rentals you grew up in, the poor neighborhoods, the landlords and landladies, the used furniture. What you can never remember, won't even know until it occurs to you as fathers, is the joy, which, like all mysteries, is wordless, impossible to describe unless you know it. The joy, the pleasure, you both are to me. How to try? Something we can share. The photo album. Too many, too much. Little Tony dressed up in blue overalls, a hammer in his hand, one of my old hardhats on, playing construction. At the beach, in a sandcastle hole, you're looking at the cameras as I take your picture, a hat that says "My Dad is a Union Carpenter", a hat that falls over your eyebrows, and you can't see over the brim, and you have to hold your chin up to look, your mouth open. You wore hats like that for years, wouldn't have them any other way. There's my little Ricardito, sitting on a white table in Ensenada, a diaper on, a smile that's never left. And there you are running through the pigeons on Olvera Street, arms wild, laughing. There's the two of you leaning over the couch, pulling back the curtains, your serious faces against the windows, watching and listening to the garbage men and the garbage truck. Another of your hot wheels plastic bikes, one red and blue and yellow, the other all black, streamers on the handlebars (they were so noisy, and that's what you liked), parked in the driveway of the apartments in East Hollywood, when the giveaway L.A. Dodger batting helmets were really racing helmets, the red framed glasses without lenses were goggles. There's the three of you, your *mami* and you two all wrapped up warm, one evening when we went to *las posadas*. But everytime I page through those photos I have to stop. The joy is too painful, bringing me to tears. I've snuck things. Watched you at lunch times at your school, in the playground. Petted your soft hair when you slept. Remember the snow days in El Paso? The gloves and extra socks and little wool hats. When I hit those fly balls to you? I did it selfishly so I could be with you, to feel your

37

strength when the ball hit my glove on that hard throw back. I've snuck reading your school papers. So good, so much better than anything I ever did. Sometimes I still wake up and see your faces, my babies, you, so vividly. I wouldn't have wanted any others, wouldn't want to change any details. As short as it all is, I've missed out on nothing with you, never once thought it was going too fast. My only complaint is the complaint about life itself, that other mystery, that there is change, your growing, change that is the very source of all the other joys as well. Passage is all of ours, and we've gone together. I miss your childhood like it was my own, no more, no less. I do miss you as my babies, and I worry, worry and worry, because I love you both. What I'm trying to say, now that I see you, tall, muscular, smart, ready to fly, able, what I'm saying is thank you, and, listen to me: always be there for your mom, who loves you more than God, and always be there for each other, be close, stay close, and remember, I'm your pops, I'll always love you, I'm so proud, and whatever cash I can give you, you know that I will, but you've got to pick up your room at least once a month, please?

Love,
Dad

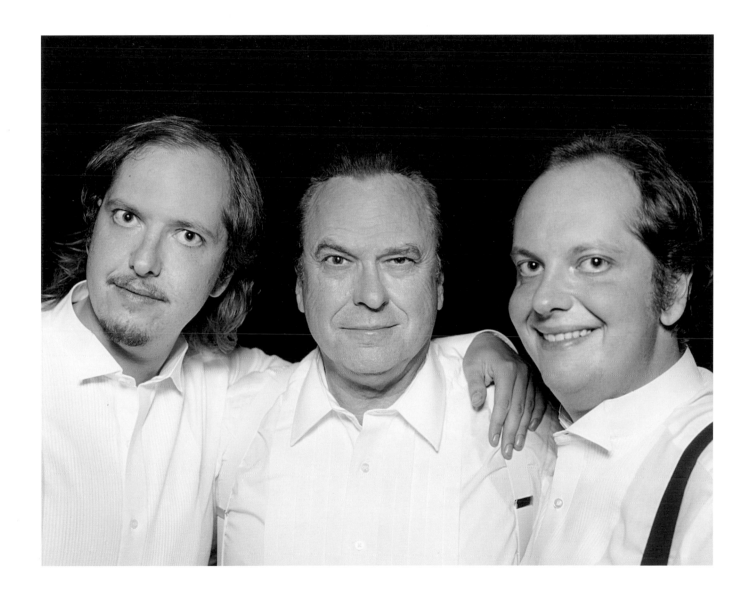

Rip Torn & sons Anthony & John

Actor / Actor and Director / Actor and Director

Tim Trickey & sons Chris Hardy Trickey & Miles T Whitten

Attorney

Born of Christmas, exactly twenty days
after and before, these sons of ours to raise.
Upon the beam shining, morn's first light,
taking only some of what they saw and heard
from the older scene and spoken word.
By eventide, wisdom, setting what is right
Lives passing through themselves, looking for their own,
in time finding it, as we are grown.

—Tim Trickey

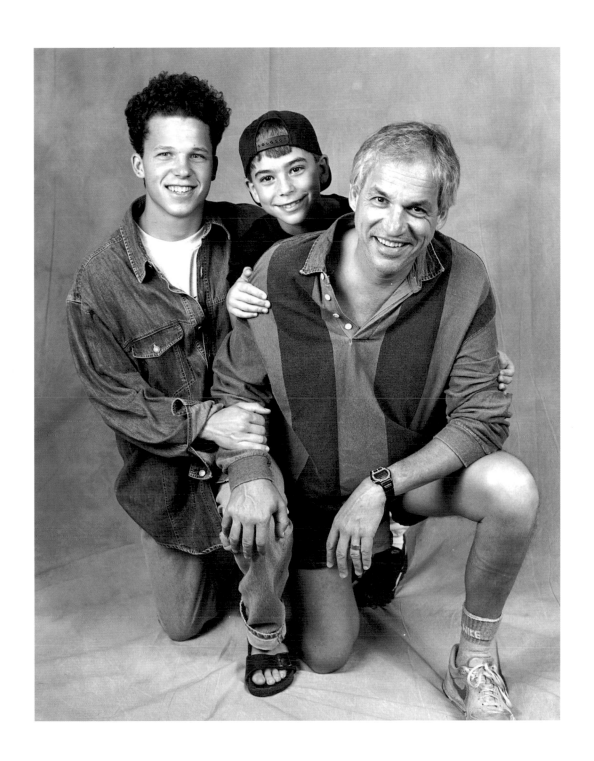

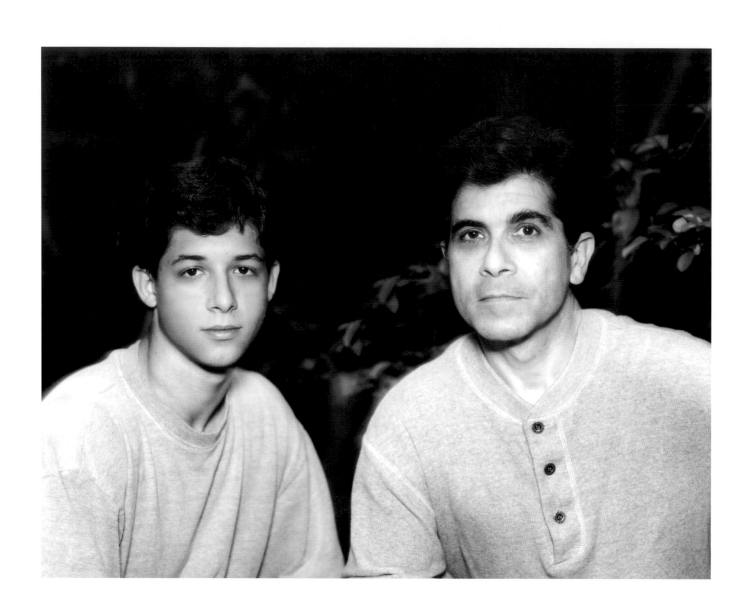

David Cohen & son Jason

Professor of Psychology

David Cohen: Of course, many fathers will say this, but I always knew that my son would turn out to be a remarkable person. It was all so evident to me, right from the beginning. For even at three or four months old, beyond his cute and cuddly ways, his searching, steel-gray eyes announced an intensity, a thoughtfulness, and something else—a mysterious potential about which I could only guess. Now, 17 years later, that potential has largely unfolded to reveal a fine and remarkably accomplished young man who continues to make his parents proud.

For one thing, Jason is gifted in mathematics and computer programming which no doubt will define the direction of his life's work while ensuring a measure of distinction. For another, he is musically talented, as evident in his piano playing and original compositions, which also no doubt will continue to bring great pleasure to him and others. In sharing these interests with his parents—interests that range from artificial intelligence to oddball comic strip humor, he has given us a renewed appreciation of many things: Shakespeare's plays, Bach's and Schumann's music, Feynman's physics, and Branch Rickie's and Jackie Robinson's baseball. For me, it has been nothing less than a second education.

An interest in things philosophical, a wry sense of humor with its clever way with words, and a mix of arrogance and humility so proper to youth: these qualities, along with a solid awareness of who he is and what he believes in, gives his life substance, direction, and a freedom from the mindless distractions and selfish indulgences that can derail those with less inner strength. Naturally, I would like to think that I had a lot to do with these and other fine qualities. But my own experience as a parent and my knowledge of the scientific data make it clear that, under normal conditions, this or that kind of rearing has a limited influence on just how a child's intellect and personality will turn out. Rather, much of these qualities that make up an individual unfold ineluctably according to an inner plan that resists alteration.

And yet, I have always tried to act as if the evidence were false as if we parents really are hugely responsible for engendering all sorts of important qualities such as values and attitudes, an appreciation of the good things in life, and maybe even a little common sense. Though we worry about these and a lot of things, the urgency has subsided now that Jason is about to enter college and live his life largely outside the parental orbit. He is coming into his own, supported by whatever nature and nurture have in store. There was a time when I fretted more—when I felt the need to let him know, that any support and guidance he would ever need would always be there. I think he knows it, now.

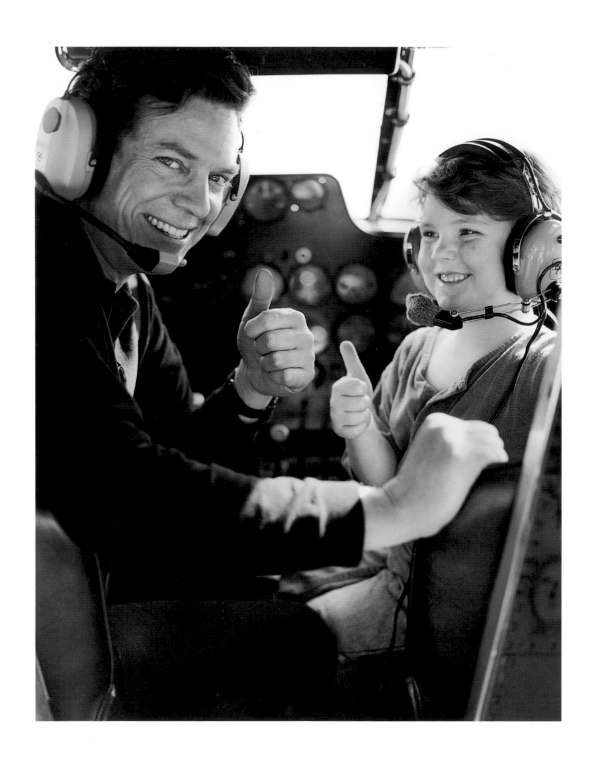

Christopher McDonald & son Jackson Riley

Actor

Christopher McDonald: The bond of father and son happens immediately and intensely from birth. There is a powerful generational blood memory of continuation from my grandfathers to my father to myself... to my son. The chain continues—family name intact.

Then comes the business of being a responsible parent; a teacher, a role model, provider, and protector.

Although the familial blood is there the roles get reversed as my son teaches me to see the world through his eyes. Each event takes on a special meaning when you share it and rediscover it with your son. The unspoken, unexplainable and unexpected moment of discovery and wonder in his young eyes. As he matures and his sense of humor unfolds, we find ourselves laughing and giggling our way through life.

As a young man, I didn't think anything could make me happier than a long winding open road ahead, the sun on my back and a full tank of gas in my first motorcycle. I didn't think anything could make me that happy again...not until I had a son.

I look forward to a lifetime of discovery with him.

Gregg Brooks & son Trevor

General Contractor

Gregg Brooks: "TREVOR," I screamed, as my son stepped onto the freshly varnished counter top. I struggled to maintain my self control as I envisioned the damage he had just done. He just looked up at me and said, "What, Daddy?" How could I be mad at the innocence of his curious and adventurous nature? In the end no major damage was done and the counter top turned out beautifully.

Such is the relationship I share with my only son. He is like a puppy in his unconditional love and admiration for me. As frustrated as I can get with him, there is no defense against his genuine, warm smile. As I arrive home from a "hard day at the office" there is nothing as rejuvenating as the heavy trodden step of him running towards me shouting, "Daddy! Daddy!" My whole being is warmed knowing how loved I am by this little guy.

I am a general contractor. Building is my business. I naturally dream of the day when Trevor can come and work with me. When I am doing home projects in the shop, Trevor puts on his miniature tool belt and comes to work along beside me. He picks up a hammer and a piece of wood and proceeds to struggle at driving in a nail that I have started for him. I watch in admiration at his determination to hit the head of the nail. I see the pride he has in himself when he shows me "how far" he has driven the nail in.

While I may have been misleading you to imply that Trevor is the paragon of patience, he is only two and a half years old. He is the poster child of a "terrible two year old." Terrible may not be as accurate as terror. The lungs with which this boy has been endowed are of world class caliber. To be in the car with him screaming at the top of his lungs is unnerving at the least. He takes such pleasure in taunting his four-year-old sister with his roaring. She has expressed in her tears what all occupants of the car feel. In addition to his loud presence, he also takes pride in rearranging the furniture. I do not mean just scooting it across the floor, but he can pick up an end table and hurl it across the room.

It awes me to see how he can go from being so rambunctious, to being so loving and gentle. Trevor can be running around creating mayhem throughout the house. I will offer to read him a book and with enthusiasm he will ask, "let me pick, Daddy." As I semi-reluctantly agree, I let him choose. I secretly hope he does not choose one of the books read so many times that the pages fall out as it is removed from the shelf. The wild thing who was running around the house a minute ago curls up next to me on the couch and attentively listens to me as I read, "The night Max wore his wolf suit and made mischief of one kind and another..."

There is no way to put into words the utter sense of closeness I feel to my son when we share these quiet moments together. Trevor is his own person as much as I am mine, but the time we share together as one father and son unit is of a richness beyond my wildest dreams.

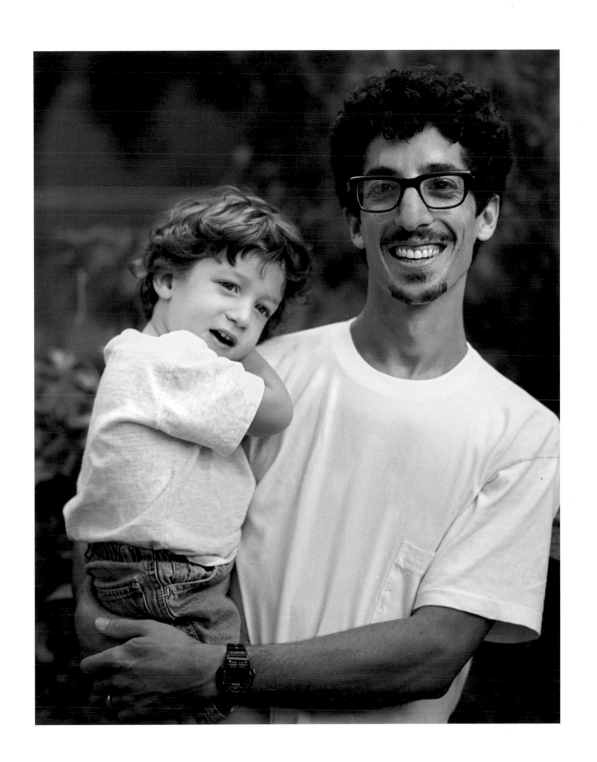

Jerry Greenfield & son Tyrone

Co-Founder Ben & Jerry's Ice Cream

Jerry Greenfield: Drip, drip, drip. The ice cream drips onto the counter and oozes onto the floor. We stand there watching it—both taking part in a conspiracy. Ever so often, a little from the big wooden spoon drips onto Tyrone's head. He laughs as if it's funny to have ice cream dripping into your hair. Kids.

Tyrone and I share a mutual love of dessert. It doesn't have to be ice cream, though it certainly doesn't hurt. Some fathers and sons go hunting together. I don't believe you can get any more primal than a bowl of Cherry Garcia. For me, just being together is enough; anything after that is gravy—or hot fudge.

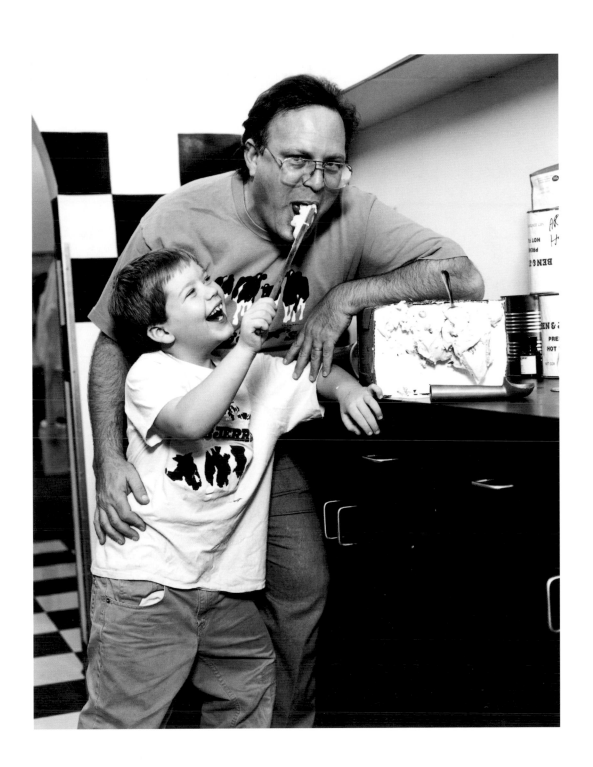

Computer Networking

Scott Poole: Patrick Alexander Poole was a very special person. He was named after my father, as well as my step father. It had been my hope, as well as my wife's, to give Patrick the things we had not had: a balanced view of life, a college education, a loving family. It had been my hope to one day see him graduate, introduce me to the girl of his dreams, to see him start his own family.

Patrick was born with a blocked left kidney, and the first months of his life were spent in intensive care. I remember that time vividly. I would work all day, come to the hospital, wash up in the sink, relieve my wife, Denise, from the vigil, and spend the night there. Finally the day came when the doctors pronounced Patrick well enough to go home. Our dreams for the future began again.

Denise spent the first few months after Patrick came home with him, but mounting medical bills sent her back to work. We made every effort to make sure that Patrick had good child care. We found a wonderful person, whom Patrick adored. Life was still rough, but things seemed to be working out.

Houston was a tough job market and work was scarce. I ended up working as a computer department manager in a large office supply warehouse and we moved from our apartment to a small house just north of Houston. This meant we were over an hour away from our baby-sitter, a new one would have to be found.

We found a new baby sitter who had two children of her own and lived in a nice area. We thought our dream would continue. However, we started noticing differences in Patrick. Although he had never complained before, he began crying when we took him to the sitter's. He was three and would say, "I don't want to go." I thought it was a phase and trivialized it by saying he just missed his other baby-sitter.

One day—it was a slow day at work—the phone rang and it was my uncle. "Scott, there's been an accident, Patrick is dead."

I don't think I will ever know for sure what happened. Patrick was upstairs in the bathtub unattended while the baby sitter was downstairs on the phone. That is all I know for sure. We decided not to press charges. I remember doing my best to convince a grand jury that taking the baby sitter to trial would not bring back my baby boy—it would only delay the healing.

It has been over three years since I have heard my son's voice and many things have changed. We left Houston and now live in a small town in central Texas. For medical reasons, Denise and I cannot have children. I try to cover over the pain with laughter, and fairly witless remarks, but deep inside there is a combination of pain and rage that I fight desperately to control.

Patrick is gone, those particular hopes and dreams have gone with him. The best we can do is hold on to our memories and keep him alive in our hearts.

Patrick, I will always love you... Dad.

David Goodnick & son Jonathan

Graphic Designer

David Goodnick: You get that first inkling about your children, when they're one or two—who they are, a hint about their personality... And I've said from that time on "I guess I got lucky." If I'd filled out a form, special-ordering the kid I wanted—bright, funny, silly, affectionate, physical, curious, energetic...looks like his mother...and all those little things I can't put into words—that's exactly what I got. I love his smile, his laugh, his blindside tackles...helping him learn to read, to skate, to trust himself....

Parenting has got to be the most wonderfully maddening thing any sane person could ever attempt. To take responsibility for starting and guiding another life is to grow up. Jon and I are growing up together.

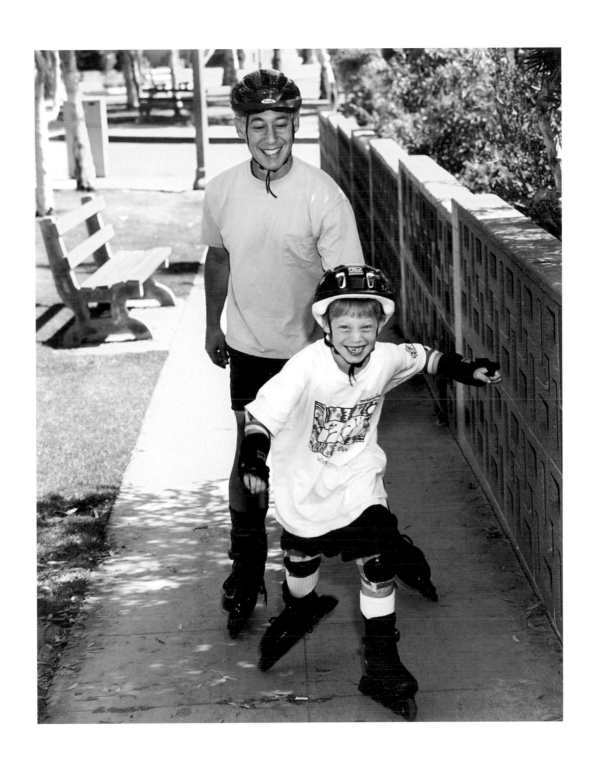

Jason David Frank & son Jacob

Actor

When I first saw Jacob it was like,
"Oh my... look at what we've done!"
The tears of enjoyment, the instant love,
and of course the fear of dropping the almost 7 lb bundle.
I was so scared that I was holding the baby too tight or too loose,
but nothing felt better than to hold my tiny little baby boy.
Having a son is the best thing in the world.
Two little eyes, two little hands, two little feet....
watching every move you made...
a love so strong that nothing in the world could take it away.

– Jason David Frank

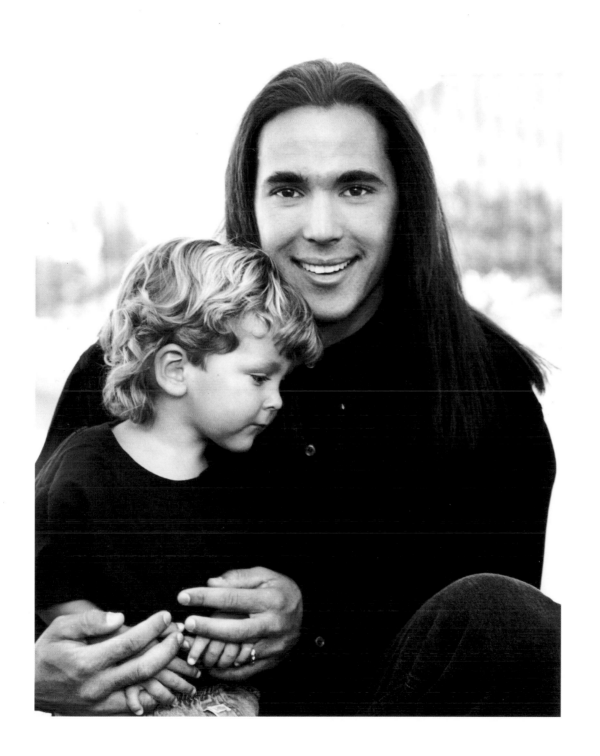

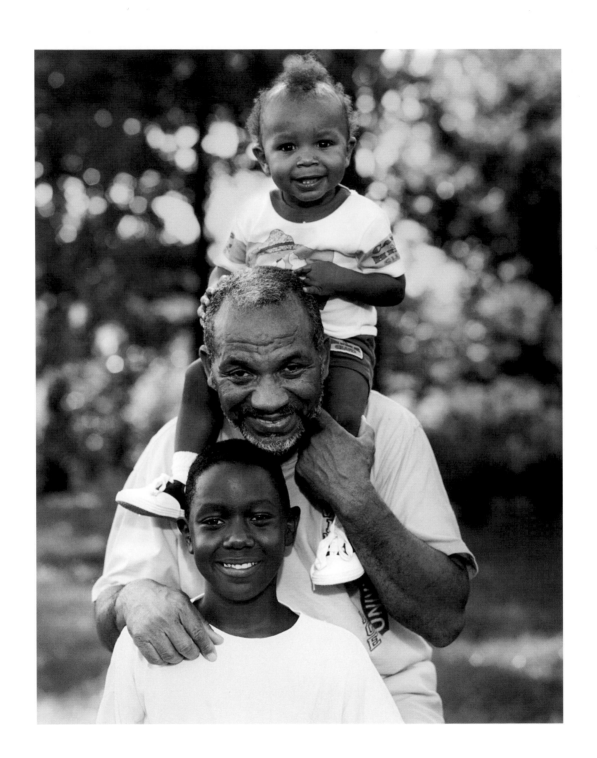

Charles Ballard & sons Jonathan & Christopher

Founder and President, Institute For Responsible Fatherhood

Charles Ballard: I am the only man who fathered Jonathan and Christopher. That means I am irreplaceable in their lives. Nothing else in my experience takes precedence over my role as father, except that of husband.

Every week, at the conclusion of church services, our family spends the afternoon enjoying each other's company and strengthening our bonds of love. Last Sunday our 16 month old son, Christopher, attempted to walk in my shoes. What father hasn't smiled at the sight of a child's feet shuffling in shoes which are miles too long? Christopher smiled at me as his clumsy attempts to walk amused the whole room. But his efforts met with less than resounding success. He stepped out of the shoes and toddled to where I sat in the easy chair. Grabbing my hand and pulling me from the chair, we walked back to where the shoes lay. Using my hand, he steadied himself and slipped first one shoe, then the other on his small feet. We walked across the room and then back again, until he was satisfied.

Children learn by example. By watching us and imitating our behavior, children develop the skills they'll need to become adults. One day they're taking their first step, the next day they are trying on our shoes for size.

A few years back, I asked Jonathan why he behaves the way he does. He has an empathy to humanity, an insight and understanding far beyond his years. He said to me, "because your blood runs through my veins."

As my children grow to become healthy, responsible adults, to become married with children of their own, the "blood that runs through their veins" will be the blood cleansed by their compassion for their family and for mankind. As they walk upon the road of life in search of answers, the road may be rocky and unsure, but they'll always stand on their own two feet, knowing in person or in spirit, I'll be there to steady them.

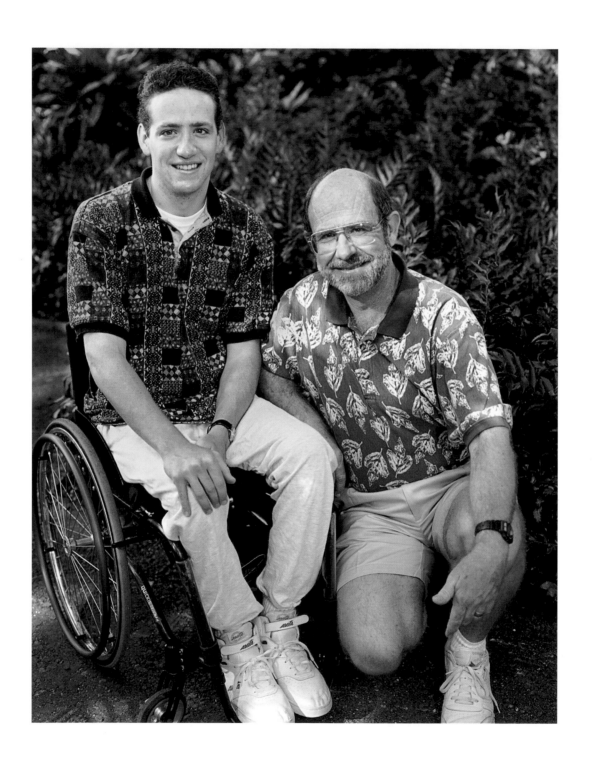

U.S. Sam Grant & son Phil

LtCol USMC (Ret.) / Law Student

Sam Grant: There is nothing in the world that can prepare a father for the phone call that awakens him at 1:30 in the morning telling him that his son has been critically injured in a motorcycle accident. It happened to me on Saint Patrick's Day, 1995. As I sat in the emergency room waiting room, hoping and praying it was a bad dream, the doctor on duty told me that my younger son, Phil, was alive, but it was clear to her that he would never ride a motorcycle again. His back was broken and he was paralyzed from the waist down. Yet, as I caught his eye when they wheeled him into the operating room, he gave me a "thumbs up" and tried to smile through the blood and the grime that covered his face. I knew at that moment that though difficult times lay ahead, "we" were going to be all right.

Like many fathers, my chosen vocation—an officer in the Marine Corps—had taken me away from my two sons for long periods of time when they were growing up. Since my retirement a few years ago, we had made up some of that ground, but Phil's four years of college at Virginia Military Institute and now law school in Austin, Texas continued to keep us physically apart. It was only by chance, I was attending a NCAA swim meet in Austin, that I was with him now.

That night, after two major operations, I sat holding his hand in ICU; he was on a respirator and hooked up to every conceivable type of equipment. He opened his eyes and with a questioning look made walking motions with his fingers. With tears on my cheeks, I told him that he was paralyzed and had lost all functions from the waist down. Phil motioned for a pencil and paper and wrote, "My sympathy for the chicks." He then made me understand through his scribbles and motions that during his darkest moment in ICU when no one was around he had been visited by an angel. The angel told him, "Phil, you may never walk again, but you will be okay." At that moment, I made a commitment that he wouldn't be alone again during this trial.

That was the first of thirteen straight nights that I spent with my son, first in ICU and then later in his hospital room. Sleep became unimportant as I tended to his personal needs and helped the nurses change his dressings. In the night, when the pain kept him from sleeping, we would talk and we would pray and we would grow closer as father and son. It was important also that we joked and laughed—even when it hurt his injured ribs—because humor is a great healer.

Two months would pass before he would be released from the hospital and he has months and probably years of therapy ahead. It is difficult for a father to see his son in pain and struggling to do things that once we both took for granted, but we work on those things together and continue to build on those commitments made during his first two weeks in the hospital. We truly do not know what the final outcome of his injuries will be; there is always hope he will walk again. We do know he will finish law school and continue with his life as he had planned it, subject to the modifications required by his new life style. Most importantly, we know that while we can't go back and change the past, we can as father and son help shape the future.

Phil Grant: When I woke in the hospital after the many surgeries and procedures, I was sore, tired, and depressed. I knew my back was broken, I had known from the moment of the accident, and somehow I knew the doctors did not expect me to ever walk again. I looked over the rails that surrounded the hospital bed and saw my father diligently standing watch over his injured son. His presence comforted me, and I knew that everything would be okay.

We had not always been close, my dad and I. He had often been away as I was growing up, and when he was home, the usual teenage parental abhorrence kept us from forging much of a relationship. However, since he had retired from the Marine Corps and I had come back to Texas after four years of college in Virginia, I had grown to understand that the strength of our relationship wasn't based on formalities and perceived closeness. Dad and I would look at each other from across the room, and somehow, although we seldom spoke about personal things, we understood each other. Somehow in those 24 years of growing up, I had come to understand and respect my father, and he in the same 24 years had done many things that shaped and molded what was now a strong young man.

Maybe that's what hurt so much looking at him from the hospital bed. I could tell that he felt my every pain perhaps more acutely than I did in my drug induced haze. I reached out for his hand, and his strong grip and stern forbearance gave me strength...and hope. Over the next two weeks my father was there during the most difficult times—the nights. He was there when I got sick, when the pain was almost too much to bear, when the uncertainty of my future weighed heavily upon my thought. Through it all, he stood tall and acted strong for my benefit. He didn't know that I could see the long hours of watching over me were taking their toll. I couldn't tell him to go home and get some rest because the truth was, I needed him there. Those dark nights were easier with him snoring in the corner of the hospital room.

It was through those nights that I discovered a father's greatest calling. They should be there for their children no matter the circumstance and no matter the personal pain or cost. They should always be there to offer a strong grip of support and hope. My father was there for me. I hope someday I'm half the father to my kids as he was to me those few short weeks. I always know, even if he's far away, he's there watching, standing guard, being there... for me.

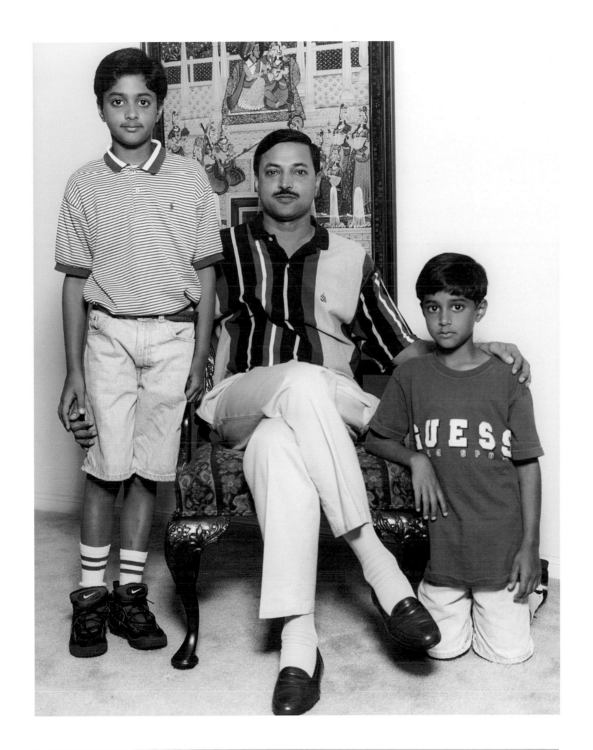

Ajay Kohli & sons Rohan & Rishav

Professor of Marketing

Ray Benson & sons Sam & Aaron

Entertainer

Ray Benson: Being the father of two boys is the most wonderful experience. Seeing these two guys who I had a part in bringing to this world, grow and develop into human beings is more satisfying and all encompassing than anything I could have imagined.

As a father it is my duty to impart as many life skills as I can to my sons. I have found, though, that I learn as much or more from my sons, about myself and about life, than I impart to them. So true, the child is father to the man.

Go out into the world, my sons, and find your way among your fellow men. Be aware of where you came from and have a vision of where you are going. Take with you the love of your family and remember, you, too, have the power to create from your love.

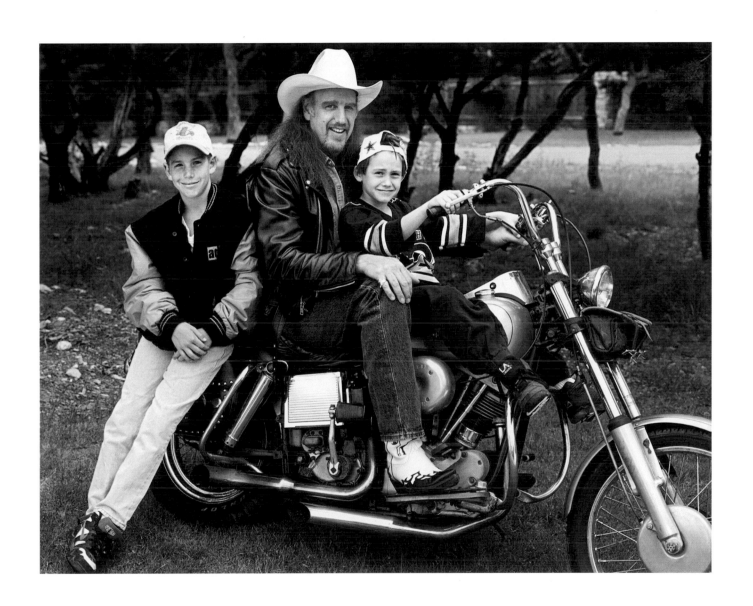

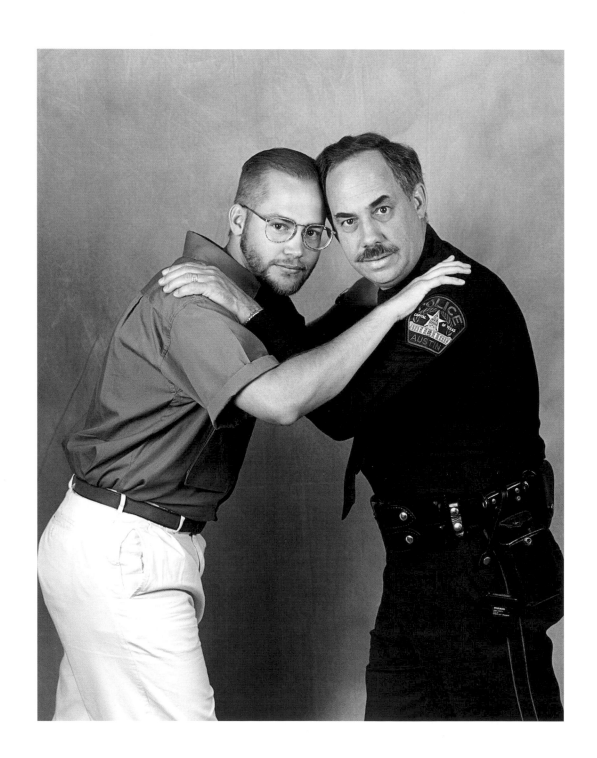

Roger Behr & son Glenn

Sr. Patrolman / Ret. USAF (Med)

Roger Behr: In May of 1969, I was a recent graduate of the Galveston Police Academy and was out on patrol. One evening the dispatcher radioed my car and told me I should run by the house because it was time to take my pregnant wife to the hospital.

I felt as if I were in one of those Doris Day-James Garner movies. Should I run with my lights and siren on? Would I be called upon to deliver the baby on the way to the hospital? I tried to control myself and show some degree of decorum.

I took my wife to the hospital and realized at that point my concern had been for naught. We were in for a long night. This was before hospitals allowed fathers to be in the labor room for the delivery. I learned very quickly that as far as the hospital was concerned, I could make their lives a lot easier by leaving and going back to work.

At 3 a.m. my son arrived in this world. I was anxious to start playing catch with him, right away. It took me a while to realize he needed to grow up, first. As he grew, we found common ground by going to the beach and even doing some fishing. It seemed we were more alike than unalike. We both enjoy the outdoors and would rather be outside than in a classroom.

The growing-up years were rocky. I didn't know my son as well as I wanted to. Glenn's fascination with the outdoors and big sky led him into the Air Force. Four years later, he returned home after being diagnosed with leukemia.

People always think it is the worst thing that could happened to a child. It's not. The years were tough, but the years before the illness were not all that great. Now, we have been given a chance to live a time over again that was not well spent. Since his coming home we have done several things together. The thing I treasure most is building a closer father and son relationship.

Glenn Behr: Webster's dictionary defines a father as a male parent, guardian or protector, anyone deserving respect or reverence due to age, position, etc... My own thought and understanding of a father goes way beyond Webster's simple definition. A father is a man, whom besides being a great role model, loves, cares for and guides me as I continue to grow.

As a young boy, I often looked up at my father and told everyone who would listen, "That's my dad, I'm going to be just like him!" I remember when I was in grade school we were having a parade of what we wanted to be when we grew up. I dressed up as a policeman. When the parade started I looked up and saw it was my father, regal in his uniform, who was leading the parade. How proud I was. I made sure, everyone in ear shot, knew it was my Dad.

Growing up is tough, and I'm sure I tried Dad's love a few times. But, as the song says, "a father's love is a love without end." It's been that love and relationship with my father that has kept us together through the years and helped me to better understand both of us.

Carey Windler & son Andrew

Orthopaedic Surgeon

Sixteen years ago I found a new friend.
That bond has grown, evolved and continues to mature.
From fishing in Port Aransas to skiing in Taos,
hiking the wilderness in Wyoming
to diving in the Caymans.
We have experienced each other.
Through all of these experiences we share time.
No greater gift could I be given.

—Carey Windler

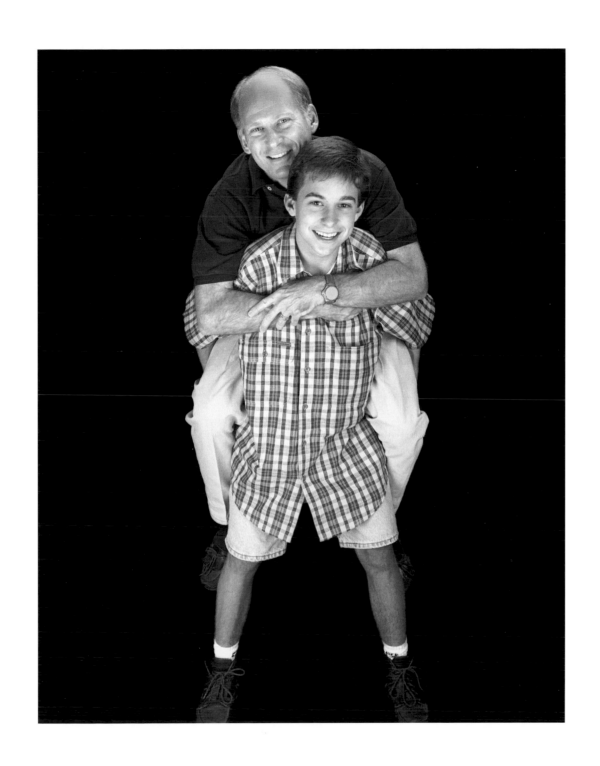

Tom Kite & son Tom Jr.

Retired / Professional Golfer

Tom Kite Sr.: I gave Tom his first club when he was about four or five years old. It was a old 3-iron I cut down for him to use. I didn't begin golfing till I was in my 30s, so I would go out pretty often and practice. Tom would go along with me and just thrash around with that club. He'd finally get tired and sleep, then start again.

I did not think he would be a golf pro. In school he always did well on tests saying he would be an architect or engineer. But, he was really hooked on golf and when he told me that is what he wanted to do, I supported him.

Tom liked golf... he liked the things I did... so, a lot of our time was spent together. Most vacations were spent golfing. My favorite is the one right before he turned pro. Back in '72, we played the National Father-Son Invitational over at Pinehurst and were the tournament winners. Since then, we've gone on to play at the Bing Crosby Pro-Am and various others, but I've enjoyed having won the National Father-Son Tournament.

A day of golfing is great with Tom because he is a good player and a good man.

Tom Kite, Jr.: I was there the day my father got his first-hole-in-one. Mom and I had already had a few, but Dad hadn't. He must have been 60 years old. We were out at the Austin Country Club playing with some old friends and he dropped it in. It was a real highlight for him and I'm glad I got to see it because he has shared in so many of my triumphs.

Dad never pushed me to be a golf pro, but on the other hand, he didn't discourage me. I think that is what good parents do. They don't decide what their kids will be and push them. They let the kids decide. Life, like golf, isn't an individual's game. You can't beat all the players out there without a great family. I come from one of the best.

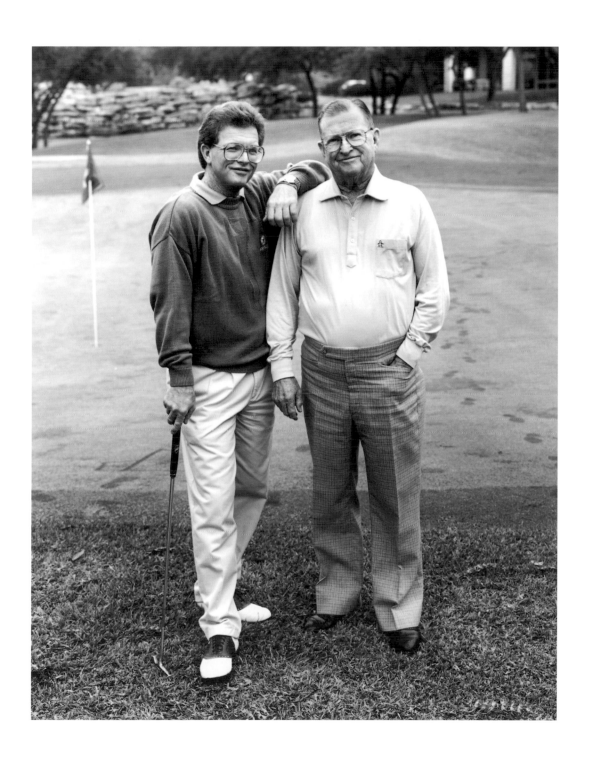

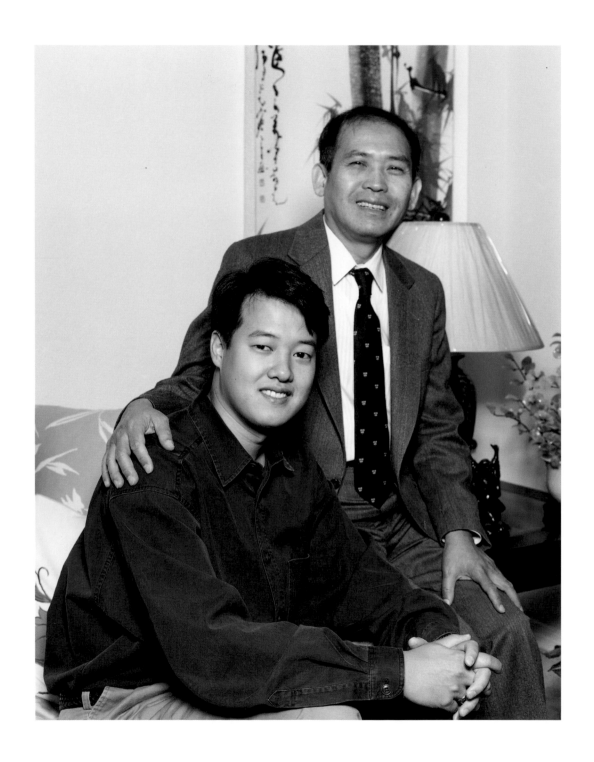

C.J. Hwang & son Victor

Professor of Computer Science / Law Student

C J. Hwang. Like most of the fathers in the world, Victor, I have limitless words and ideas to discuss and exchange with you. I want to talk with you not only about your hopes and dreams, your life, your pain, your joy and frustration, but also about the world. I want to discuss our ancestors, Asian philosophy, Chinese civilization, Taiwanese culture, western Christianity and its teachings, American democracy, and how society's values have been deteriorating. But it seems that when we come together, we seem only to discuss "day to day" topics; we ask each other, "How are you, son?", "How are you, Dad?" Even so, I believe that we both have the desire to discuss many more topics and to discuss them with more depth, and as a result, this desire has created a very strong bond between us.

I still remember a topic that we discussed not so long ago—the theory of a person's success. A person's lifetime achievements, social status, and professional success depend on a combination of three factors: intelligence, diligence, and opportunities. Intelligence is inherited, but no matter what level of intelligence a person has, he can pave his own path by emphasizing diligence and hard work. But success with only these two factors is narrow and confined. If you add the third factor, opportunity, your chance of success becomes wide and unlimited. Encountering opportunity is mostly based on one's personality. Through applying and adjusting one's personality to fit different situations, and by helping others appreciate one's friendship and support, a person is able to skillfully affect his chances for opportunity. Together, these three factors of intelligence, diligence, and opportunity help and guide one to success in life. I have confidence that you will skillfully apply these three factors in your life.

Your mother and I realize how thankful you are that we provided you with a fine education. We also know that you and your sister are grateful since we have provided both of you beautiful childhoods.

Likewise, we are grateful to you and your sister for bringing us tremendous warmth and happiness, like many other children in the world have done for their parents. Your powerful valedictory speech in high school gave us immeasurable joy and happiness. The most priceless memory of all, however, is when you graduated from Harvard. The joy and feelings your mother and I will experience when you receive your J.D. from the University of Chicago next spring will be difficult to put into words. We are confident that you will be a successful lawyer or statesman.

Although these are your personal achievements, these have also made all of our lives and souls very fruitful. The support and assistance your mother and I have given you does not compare to the joy we have received from you in return. Just like one Texas singer sang, "Tell me, how did you know just where to find me?... Who showed you the way to my heart?" Thank you very much for giving us so much joy. Thank You, Son.

Victor Hwang: Chinese fathers and sons almost never show their emotions openly. As a result, my father and I are not good huggers. We are not good at saying I love you. We are not good at talking about sensitive subjects. But love, in the deepest sense of the word, comes in many shapes and sizes. My father and I share a unique love—a love where actions speak louder than words, where hugs are somehow inadequate expressions, and where we both understand that the truest love does not need to be spoken to thrive.

My father has been many things to me—part hero, part giant, part scholar, part teacher. It is hard to imagine the world from which he came: a small town named Linpien on the southern end of Taiwan. His parents owned a small store, where they made a modest living. My father and his siblings took turns carrying water buckets back and forth from a well. Living conditions were rough and rustic. People worked hard.

The odds which my father has since defeated are staggering. Where college was the exception for Linpien children, rather than the rule, my father fought his way into Taiwan's best university. Although the dorms in his college required lights-out at ten o'clock, my father would often sneak out under the street lamps to study a few extra hours. When he and my mother braved the trek to the United States in 1970, they came with not more than a few hundred dollars and a few bags filled with bare belongings. As he pursued his Ph.D, my father raised his family on scarcely three hundred dollars a month. I am amazed sometimes that we are where we are, that we did not get buried beneath the furies fighting against us. Some say the American Dream has passed away. I would respectfully disagree. My father, the professor, is living it today.

The values by which my father has lived so well—do your best at everything—he has also impressed upon his son. I remember, very vividly, one particular event in third grade. That day, my school teacher had introduced multiplication to the class. A mere introduction, however, was not enough for my father. So that same night, he kept me awake past midnight, until I had learned the entire multiplication table—nine times nine equals eighty-one, ten times ten equals one hundred. I spent the next several weeks attempting to stay awake, while my teacher tried to instruct the rest of the class on what I had learned in a single night.

My father has never been satisfied with average. He has always pushed himself, and he has always pushed me too, further and further, higher and higher. His ambition, his determination, his guts—they are part of me. My father has always said, "Your success in life depends on three things: intelligence, hard work, and luck. Of these three things, you can only control how hard you work. So that's what you have to do: work hard."

My own youth, in contrast to my father's, has been easy. I never had to cart buckets of water. I never had to study under street lamps. I never had to start my life over, half a world away. True, I will have my own battles to fight. But my task, you see, will be easy. I have the teachings of a hero. I have his experienced hand to guide me along. And sometimes, when I get lazy, I even have his encouraging foot to kick me in the rear.

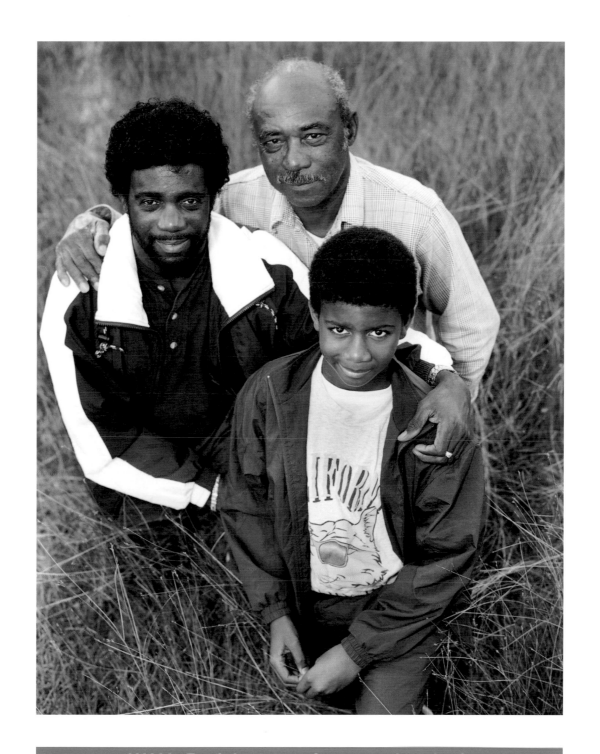

**Will Robinson & son Jack &
grandson Jack Jr.**

Retired / Municipal Bus Driver

Mike Harlan & sons Cody & Caine

General Contractor

Mike Harlan: I was adopted. Never have I known a person whose blood I share. That changed the day my son, Cody, was born. Nothing can prepare you for that moment. There was a tidal wave of loving and wonderment. Every day I watch as Cody, my own flesh and blood, becomes more and more like me. He and I share a common love: motorcycles.

Baby Caine is only eight months old, but he has already enriched my life. No matter how hard of a day I'm having, his big loving smile overshadows the pain a hundred times over. In their own way, they say, "Don't worry, Dad. It's going to be okay." Hearing it from them, I believe it.

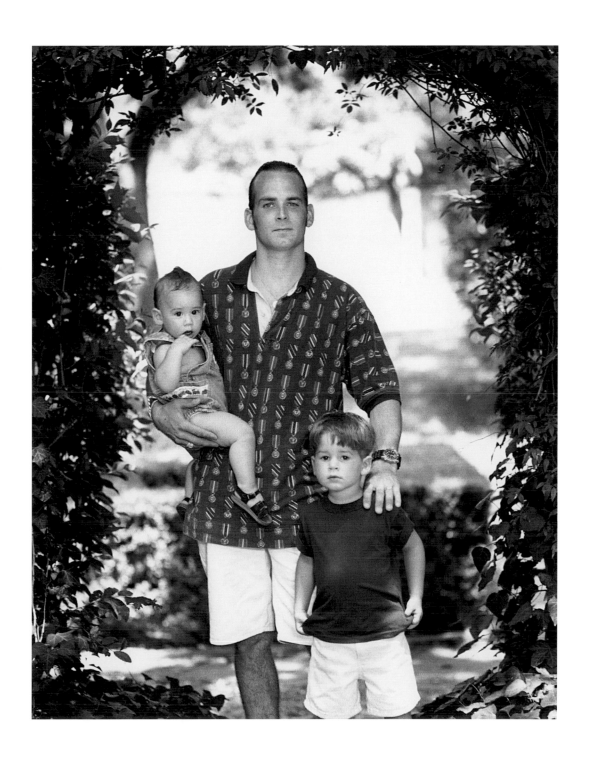

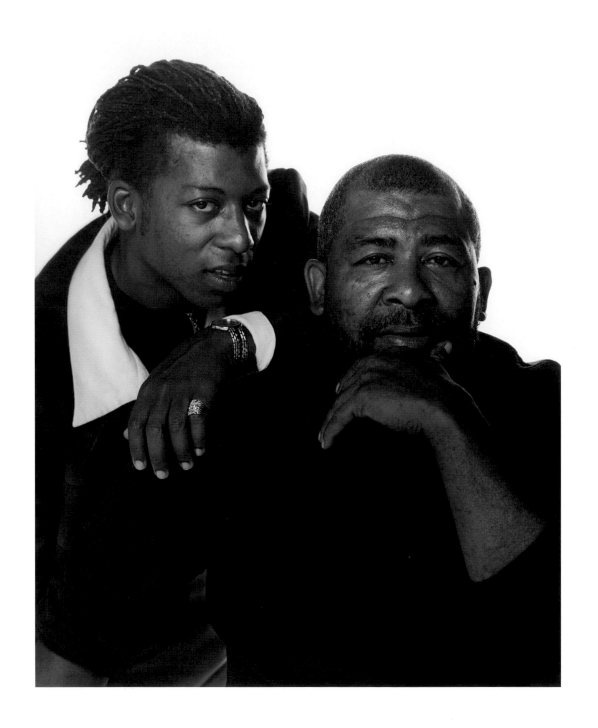

Elvin Girdy & son Kelvin

Lithographer / Stand-Up Comedian

Kelvin Girdy: Three years ago I was working in corporate America and wasn't happy. I made a life changing decision and called my father. "Dad," I said, "I'm going to be a comedian." He burst out laughing. I never knew comedy was this easy.

Actually, comedy isn't easy and that is the reason I wish my father were in the audience at every gig. I would put him right in the middle and let him rip. No sly smiles or slight chuckles. No way, not for my father. Dad has a belly full of laughter.

Being a comedian/actor can get very stressful because there is always someone around you telling you can't do this and you can't do that. But my father is never that person. I guess it is because in his younger years he was also an entertainer. He remembers how hard it is to make it on the road and a performer needs all the support he can get. Dad is always saying, "doesn't matter what is going on in your life, son. You've got to pick yourself up and then move on. Learn to put your trust in God."

We are dedicated to God. We are also dedicated to each other. Through this dedication we will make our relationship stronger and help those around us. We are blessed.

Steve Kroft & son John

CBS News 60 Minutes Correspondent

Steve Kroft: I became a father well into my 40s, having no idea how much it would change my life and the way I look at things: my job, my time, my future, even my politics. The hours I spend with my son John on Saturdays and Sundays are not just the highlight of my week, they have become the best times of my life.

I am amazed how much he knows even at 18 months, how much of his personality is already developed, how much he is already a boy. He will drag me into the front seat of my old sports car, and demand to sit on my lap so he can turn the steering wheel, and pull at the turn signals, imitating my every move, anxious to show me how much he has already learned.

He will lead me off on long walks with the dog looking for deer and squirrels. We explore a world that changes for him every week in size and wonder. Trying to look at things through his eyes has given me a second childhood; an opportunity to see everything again for the first time. Being with him takes me back, in short flashes, to my own childhood and the time I spent with my father, and his father, reminding me of sights and sounds, days and moments, that had been lost from my own memory for decades.

Regardless of what is going on in my life now, I look at him and think, "This is important. This is why I'm here."

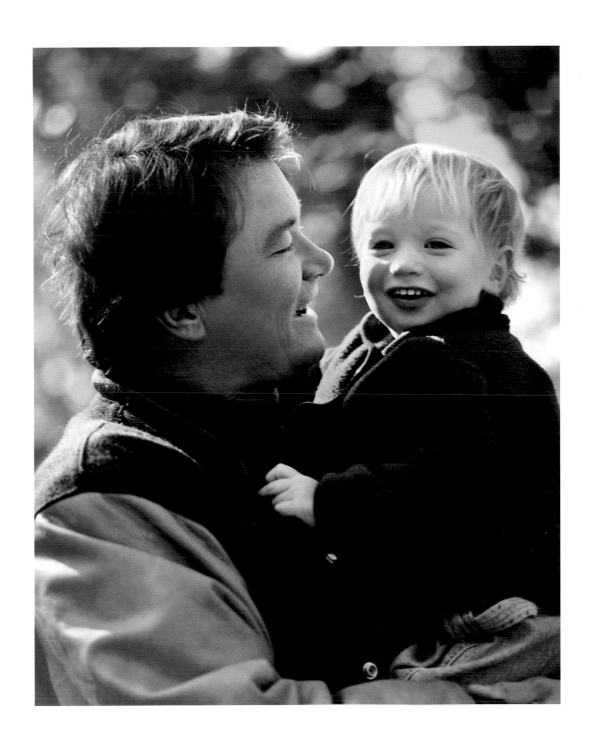

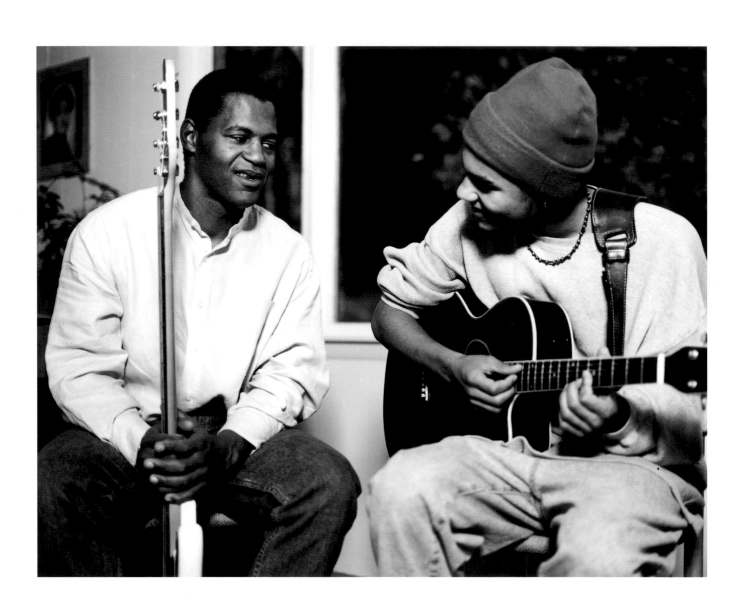

Gamal Buhaina & son Lee

Musician / Student and Musician

Gamalle Buhaina: Lee spent a majority of his life in Dartmouth, Massachusetts with his beautiful and altruistic mother, Marlene. She is the fountain of love and nurturing from which Lee has grown. During the summer, at 16 years of age, Lee moved in with me. Thus, began our living together on a full time basis. I knew there would be challenges with day-to-day living under the same roof, but I never realized how rewarding it would also be.

We share many of the same friends and interest and do things together like hiking, boarding and going to concerts and parties. Perhaps our favorite is playing music together. When music flows, all barriers cease and movement begins. Lee is a gifted musician not afraid of intimacy, and this is evident in his style and in his message. This is where our bond gathers much of its strength. I hear the music pour out of him, it raises the hair on the back of my neck. Whatever I was focusing on at that moment fades and I just want to join him. My son, he is a beautiful man. He is my greatest teacher. To drive down a country road taking in the beauty of the maternal mountains of Vermont, to share and to just talk about things that most parent/child relationships do not even begin to consider is the greatest gift of all.

All bonds begin with some form of communication. To create and maintain a healthy environment where people can communicate without inhibition is an important responsibility. A parent must remember that they too have a lot to learn. I believe that children are to be both seen and heard. Listen to you children and above all, trust them. My father, the late great Art Blakey, also known as Abdullah Buhaina, would always say, "He's my son...we do everything together." Lee and I shall keep carrying the message.

Lee: I didn't know my father very well when I was a child. I only saw him a couple of times a year. The one time I was sure to see him was at Christmas. One Christmas eve, Mom and I were out visiting friends and we came home about one o'clock in the morning and Dad was sleeping on the front porch of our apartment in the snow. I was so happy that he was there. I had prayed all the way home that he would be.

When I was twelve I began spending more time with my father. As each year passed from that point, I spent more and more time with him. I came to know him better and feel more at ease with him. Our relationship has continued to strengthen as time has passed. I moved into Dad's house almost two years ago. I feel lucky because my dad understands me. More importantly, I am certain that he trusts me.

Gabor Szabo & son Austin

Attorney

Gabor Szabo: The moment my wife, Clara-Lisa and I found that we were expecting a baby, old vices went out the window. It was scary, the old adage "monkey see, monkey do" was soon to invade my territory. So, it is being a father.

My wife says this means I cannot watch TV anymore. It also means that we live and breathe our children. After school, they come home for homework and Clara-Lisa helps them do it, while I put together another train set... and sneak in the news. Dinner time is important, the little ones dictate where the conversation goes. Bed time is more important. Stories are read and secrets are told. Shaping and guiding them to be good, compassionate citizens. We want them to work hard and be kind and sensitive. In short, fatherhood means I have to do all of these things first. Monkey see, monkey do.

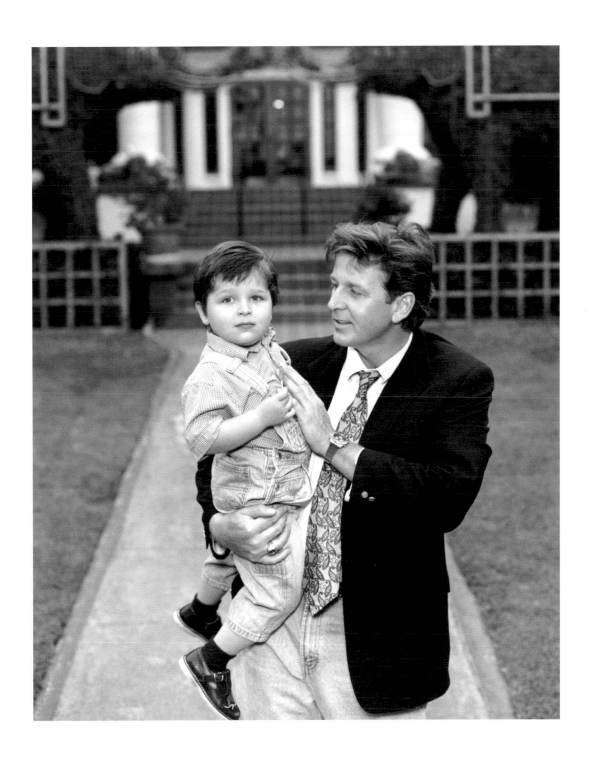

Doug Borgman & sons Patrik & Jamee

Dentist

Doug Borgman: When I was growing up, my dad, Col.(ret) John Borgman, and I were often separated by his work. He was in the military and would often be gone for months at a time. This was during the Vietnam era when many fathers left and never came back. It wasn't until later in life that I was able to appreciate what sacrifices my father made for me.

In picking my career I decided I wanted something that would keep me in one place permanently, so I could be with my children. I was blessed with two beautiful boys: Patrik, the oldest at 12, reminds me a lot of my father; and Jamee, ten years of age, reminds me of my wife, Beth. Alas, both boys are now at the age of parental defiance, independence and spending as much time with their buddies as they can.

One night a few months ago, Patrik was at home with us on one of the rare occasions when there was nothing else to do, but get stuck at home with the parents. We decided to rent a movie from a store down the street. Beth and I waited in the car while Patrik searched for his heart's desire. We saw him come rushing out between two parked cars, with a big smile on his face letting us know he had found it: the coveted super Nintendo game. Suddenly, a speeding car came to a screeching halt as Patrick tried in vain to dart from its oncoming path. His leg got caught on the bumper and he was hurled over the hood onto the asphalt parking lot. He was shaken, but alive.

What a wake-up call! The entire family realized how lucky it was to escape tragedy. It's just too easy for everyone in the family to go about our separate ways and get used to it. I don't want Patrik or Jamee growing up and thinking that their father has gone off to some war, when I've always been in their own back yard.

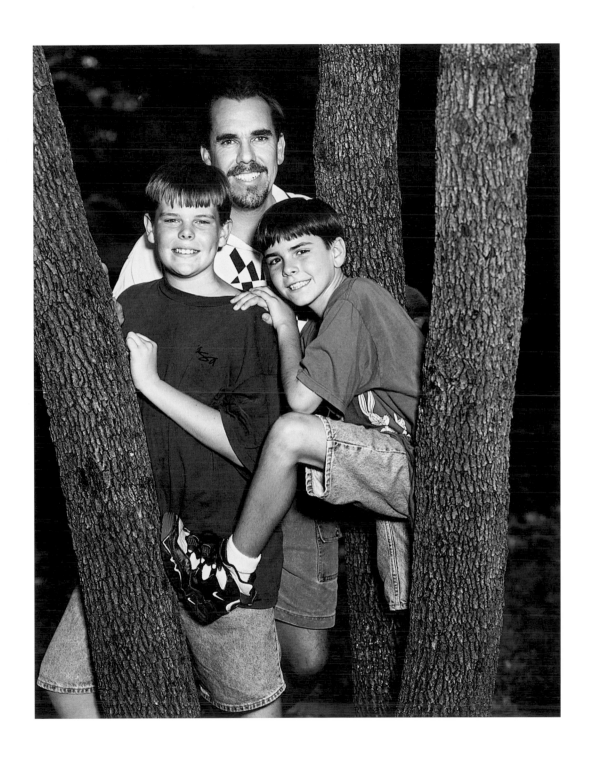

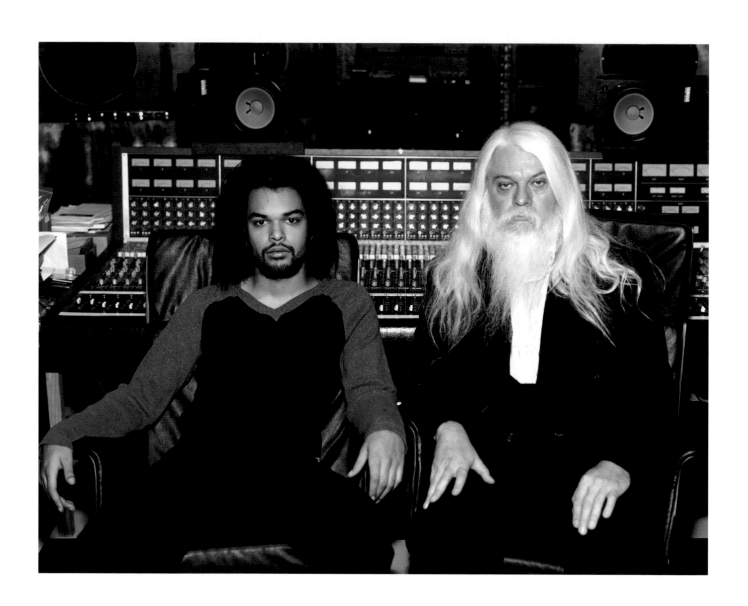

Leon Russell & son Teddy Jack

Singer and Songwriter / Engineering and Producer

Traveling into the shock of the future
 with luggage of the past in hand
 Staring out in the chaos of possibility
with childish expectations
 and the memories of dreams dreamed
Searching for a glimpse of the answer
 in a tomorrow somehow better
I see a figure approaching in the distance
 singing new songs
 with new stories to tell
He walks in a deliberate way that is familiar
 and carries answers in his heart
As he holds out his hand to help me
 I look up and see
 The face of my son
And my soul is satisfied

—Leon Russell

Teddy Jack: My father has always given me unconditional love, respect and understanding. As my life unfolds, I know he'll be a never-ending source of strength and support for all of my goals and ambitions.

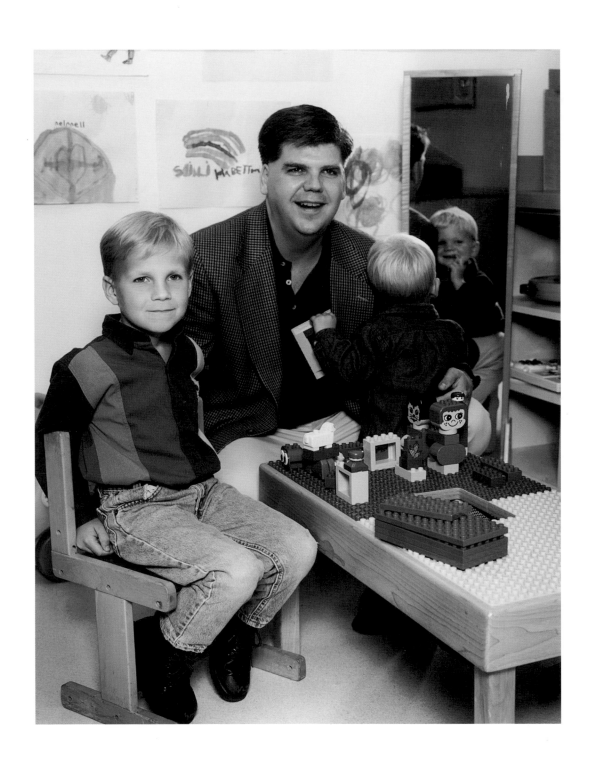

Jim Kitterman & sons Ben & Billy

Executive Director Candlelighter Childhood Cancer Foundation

Jim Kitterman: As a father of a survivor of childhood cancer, I have a very special relationship with my eldest son, Ben. He was was only three at the time of diagnosis. During the subsequent treatment for cancer, and during his bone marrow transplant, I took a year off from my career to serve as his primary care giver. It entailed spending endless and sleepless days and nights with him in the hospital full of questions and confrontations with doctors and nurses. I wanted to make sure he was receiving the best possible medical and supportive care. I was by his side doing what I thought any father would do—holding his head up and stroking the little hair that remained while he vomited from the chemotherapeutic drugs. I would rock him in my lap following a painful procedure and give him words of encouragement.

There was no question about what I was doing or why I was doing it. This was about my son. There is a bond between us that will never break no matter what "difficulties" we might face as he grows up and begins to assert his independence.

Ben is not my only son. My other children are no less loved or special to me and my other son, Billy, is no more or less of a son to me than Ben. And herein lies the dilemma. With Ben's cancer, I was given the opportunity, albeit an undesired one, to express my unconditional love for him and establish trust, respect, and love, which are critical to any relationship. How will I be able to show Billy that my love for him is no less or no more than it is for his brother?

I do not believe that there is an easy solution to this delimma, but rather, I think it is only through being kind and loving, being a teacher and a supporter, and mostly just being there for him that the same trust, the same respect, and most importantly, the same love will exist between him and me that I have found with Ben.

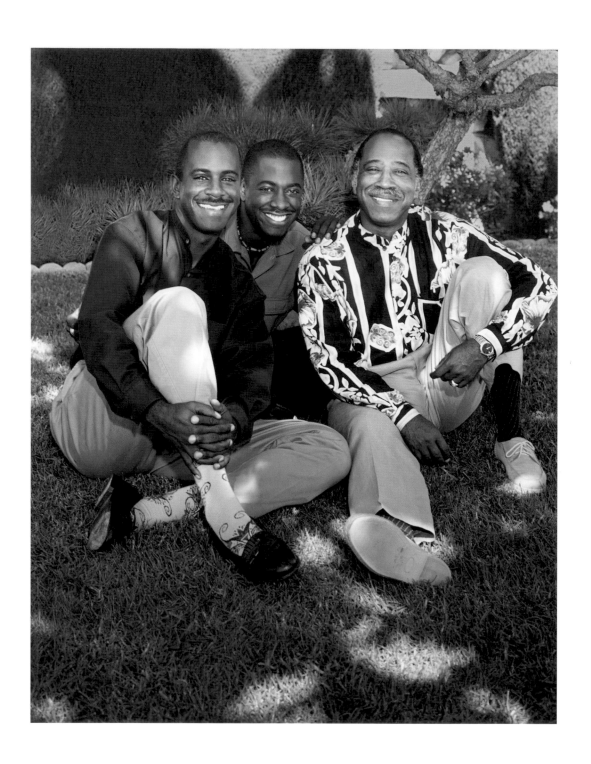

Samuel Biggers Jr. & sons Sanford & Samuel III

Neurosurgeon, Professor of Neurosurgery at Charles R. Drew University / Artist / Chemistry Professor

Samuel Biggers: On a winter day, 33 years past, a soon-to-be neurological surgeon, stood at the threshold of a darkened apartment. On his arm was a very pregnant wife and inside, the room was crowded with silent celebrants of a baby shower. Abruptly, the space came alive with a concerted, "Surprise!" Unsuspecting and startled, the wife went into labor. It sent me into a wild assortment of musings and insights.

I reflected on the baggage we inevitably bring to fatherhood. My thoughts brought new understanding of my own father. For the first time, in my consciousness, it occurred that the genetic material, the specific genes that would ultimately define my unique being had of necessity been extant in some distribution of those individuals who emerged on some primal African Savannah in some far distant millennium. Now, I stood as the nexus to those legions of generation for my own offspring. If I had some inchoate notion of the cosmic significance of becoming a father, it had not expressed itself in organized thought until that defining moment. That thought was at once humbling and hubristic.

These musings, disrupted repeatedly by the anxieties of labor and delivery, culminated in the joy of a firstborn son. It was an exhilaration to be renewed with a daughter and then another son in years to come.

To be totally vested in the growth, development and maturation of three unique personae proved to be the most profound link in my own development and maturation. This opportunity to discover in myself that unplumbed capacity for that unconditional love. Through them I recapitulated my own passage from innocence to experience, and eternal naïf that I am, sought to do it "right" this time. It was an inevitable temptation of my parenting, that quest for a near perfect childhood and yet each in his own way is as wonderfully flawed as their father.

Sanford Biggers: Three, bound by blood and love, discovering yet unplumbed depths in their relationship. Two, sons of a son of a working man, viewing him again, for the first time through lens of manhood shared. One, with the resonance and tone of new found independence and duty. The second with the glow and smile of a newly lost creative virginity. He, with pride and unconditional love. All, suffused with the blessing of respective passages over time to this moment—boys ever father to the men. They, beyond this cross path, when nocturnal addresses open with, "Our Father" will sense that utterance in new dimensions.

Ken DeAngelis & sons Ross & Nicholas

Venture Capitalist

In a divorce the role of parent becomes tangled.
The adults feel at a loss and the kids follow our lead.
Psychologists tell us that kids have to adapt and re-establish
their trust in their parents.
That happened for me in the most extraordinary way.
While playing out in the yard, Ross fell off a barrel
He was trying to reach up into a tree,
Instead, he fell and broke his arm
Through the howls of pain,
Brother Nicholas came tearing into the house to get me...
I was there.
Even though our home had changed,
I, their Dad, had not.
It was a good lesson for all of us.

–Ken DeAngelis

Dick Van Patten & sons Nels & Jimmy

Actor / Tennis Professional / Actor

Dick Van Patten: My father taught me to play tennis and never once did he throw a game so I could be victorious. Dad said it didn't matter who you were playing, you should always play to win. It took me a few years before I beat him.

I am blessed with three wonderful sons, all a year apart. God gifted them with great looks, physiques and character. I gave them the Van Patten tradition: tennis.

When each of them got to be about ten years old, I would give him a tennis racket and teach him the basics. When they were eleven years old, I could beat them. At twelve they would win a few. At thirteen I would win a few. At fourteen, I quit playing against them. They were just too good.

Today, watching them in their work, their play and their lives makes me so proud. Jimmy, my middle child, has starred in 20 motion pictures and wrote a 45 minute video called "Dirty Tennis" which won the New York and VSDA Awards for Best Comedy Video of the Year in 1990. My son Nels in 1986 became the National Singles Paddle Tennis Champion and held that title for three years. My youngest, Vincent, was a professional tennis player. In 1981 he was voted Rookie of the Year and beat the number one tennis player, John McEnroe, twice that year. He accomplished this simultaneously while he was successfully acting.

Lou Gehrig said he was the luckiest man in the world. However I have to disagree. All three of my sons live within four blocks from my home and I am privileged to see them and my grandchildren almost everyday. What more could the luckiest man in the world want?

David Pantuso & son Chase

Realtor

David Pantuso: Chase is the perfect son. Perfect enough for two fathers; I am his adopted father. He is strong, smart, sensitive, loving, caring and helpful. At this stage in his life, he is wanting to be a scientist so he can dig up dinosaur bones.

As a father, I am working hard to teach Chase to be himself, not to be afraid of anything, to have respect for himself first and how to respect others. Respect is a big word and covers a lot of things. He knows right from wrong, good and evil.

Every night I am reminded of how blessed I am when I carry him to bed and tuck him in. I whisper, "I love you," in his left ear. Some nights, like last night, he is just too tired to talk and he just smiles ear to ear. There is something special about a love from a child. I would do anything for him and he knows it.

Robert Jackson & son Bobby

Pastor / Stock Control Manager

Bobby Jackson: As a child I dreamed of being two things. One was to be a pro-football player, the other was to be like my Dad. When I stood only a few feet tall, my Dad was my world. I followed him around the house putting the toothpaste tube down just like he did, or I would hide behind the newspaper and peek around to see if he had flipped the page he was reading. His rituals became mine. When he was away at work, I'd stand in front of the mirror and imitate his voice, his posture. I guess it was like some kids play-acting as if they were policeman or fireman. I just wanted to be like my Dad.

I learned a lot from following Dad around. I learn that if you have a child, for goodness sakes, love them. Let them know you love them. Be in their lives, for there is no greater gift than a father's love.

As for being a pro-football player; well, it would've been nice. But, I'd rather be like my father. Thanks, Dad.

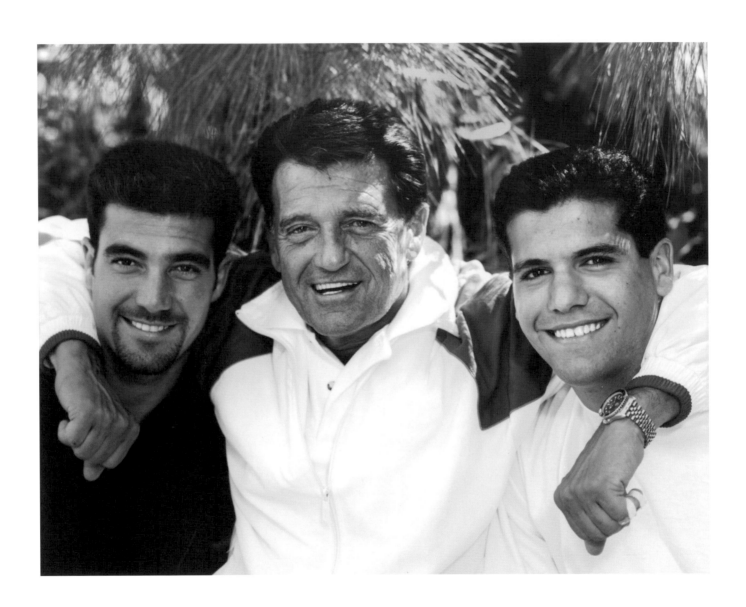

We got it from our father
and was the best he had to give.
And right gladly we bestowed it,
It's ours the while we live.
We may lose the watch you gave us
and another we may claim.
But we'll remember when we were tempted
to be careful of your name.

It was fair the day we got it, and a worthy
name to bear, when you took it from your
father, there was no dishonor there.
Through the years you proudly wore it, to
your father you were true. And that name was
clean and spotless when he passed it on to you.
There's much that you have given, that you value
not at all. You have watched us break our
playthings in days when we were small. We have
lost the toys you gave us, and scattered many
a game, but we will never hurt you father, because
we'll be careful with your name. It's ours to
wear forever, ours to wear while we live,
ours perhaps, some distant morning to another
boy to give.

And you'll smile as did your father-with a
smile all can share, it's a clean name,
and a good name, you have given us to wear.

—Jacky & Jason Gilardi

Director of the Pritikin Longevity Center

Robert Pritikin: Imagine living your childhood in a suspenseful detective movie. Every night my father, the inventor, would come home and before he could get a word in, I'd ask, "What happened with today's experiment?" He would patiently tell me the results—which usually posed more questions than answers—and then he'd ask, "What experiment should we design to solve these new questions?" He knew exactly what to do, of course, but guided me into designing the next day's experiment. Over the years, my father pretended to let me invent countless patents.

This pattern continued until finally in 1974, under my father's direction, I managed and co-authored my father's greatest experiment: the first clinical trial using a low-fat, vegetarian diet and walking program. Our subjects were 19 cardiacs from the Long Beach VA Hospital, and the goal was to determine whether my father's approach could reverse the course of their diseases. The results were so impressive that they led to two *60 Minutes* specials and the opening of the Pritikin Longevity Center in 1975.

Almost 11 years ago, to my great sadness, I lost my father. But I have never lost his inspiration. When we publish scientific studies today, my greatest joy is that I can still hear my father saying, "Robert, what experiment should we do tomorrow?"

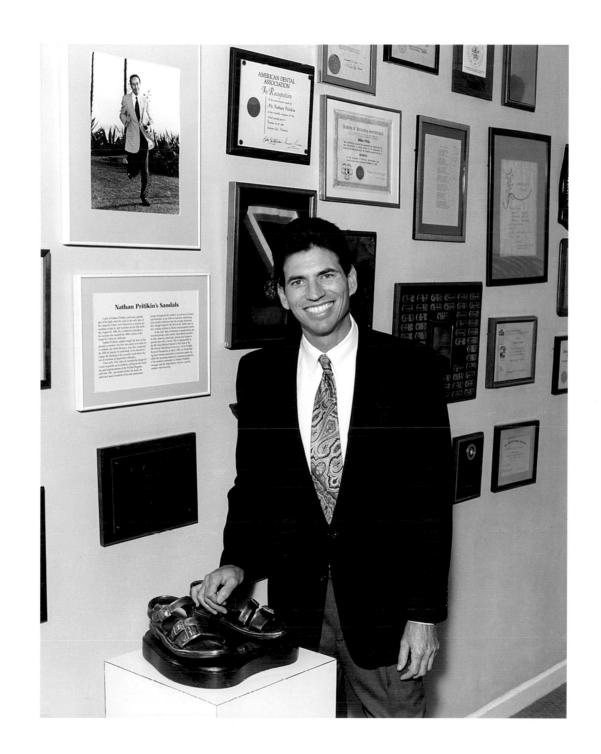

Jerome Kuntz & son Jerome Jr. & grandson Scott

Commercial Shrimpers

Jerome Kuntz: I got my love of the sea from my father. I began shrimping with him when I was only an infant. He had sold our old Pontiac to get enough money for his first boat. Before long, I was working longer hours and studying less. I left school in the 7th grade and I've been shrimping ever since.

You learn a lot on the water; about hard work, taking chances and commitment. It is a good learning place to pass on values and a work ethic. My boys—all six of them—had to take turns shrimping with me. I couldn't make them like it, but I could make them go. They went. I know it kept them out of trouble.

My dream for my kids was for them to do what they "like" to do for a living, not the only thing they could do. To me, that meant they had to finish high school, no choice.

I am the father of six boys and four girls. My life work has been hard, but I have ten of the best friends anyone could have. It is a good life.

Jerome Kuntz Jr.: Pop worked 360 days a year; shrimp in the summer and the fall; oysters in the winter, and fish in the spring. Mom has always said that Pop has salt water in his veins. A fisherman's life is tough. They fight adversity—both natural and man made. It is a constant struggle. I ran a small boat for him out of high school and he has always supported me in what I want to do. Shrimping is still good therapy for me. My oldest son, Scott, loves the water and has the same salt water running through his veins as his grandfather. He heads out to be with Pop any chance he gets. Whatever path he chooses, I hope I can be as supportive as my father has been for me. I know Scott has the best proof in my father: nice guys do finish first.

Jim McKinnis & son Dylan

Photographer and Author

Jim McKinnis: When I was twelve, my dad and I went to a major league baseball game in St. Louis. It was the only major league game we attended together. Forty years later, it remains one of my best memories.

When Dylan was born, I decided that before time erased the opportunity we would also attend a major league game. A few summers ago we mapped our route. For seventeen days we would "road trip" to four of the ball parks which remained from when I was his age: Yankee Stadium in New York City, Fenway in Boston, Tiger in Detroit and Wrigley Field in Chicago. We agreed on food, number of hours to drive, and, most importantly, music.

Seeing baseball in the hallowed walls of time was terrific. At the games we lost ourselves in the drama: the crack of a bat, the circling runner, the tension of a full count. On the road we lost ourselves in conversation and in silence.

One evening, on a long drive day, I was at the steering wheel and Dylan napped in the front seat. I started thinking about the ironies of life. Before Dylan was born, I had decided to forego fatherhood. As with many of life's pre-emptory decisions, I would never have known what I had missed because there is no way of expressing the profoundly basic sense of love and satisfaction having a son has brought me.

It was evident in that first moment after Dylan's birth, when I held him, that I was experiencing an emotion so elemental—life had taken on another meaning. Fourteen years later that bond has been shaped by successes as well as hardships.

Looking over at his sleeping face, I realize the best decision I made was to become a father. I felt that way then and I feel that way now. Long after the box scores fade, I'll still be Dylan's dad.

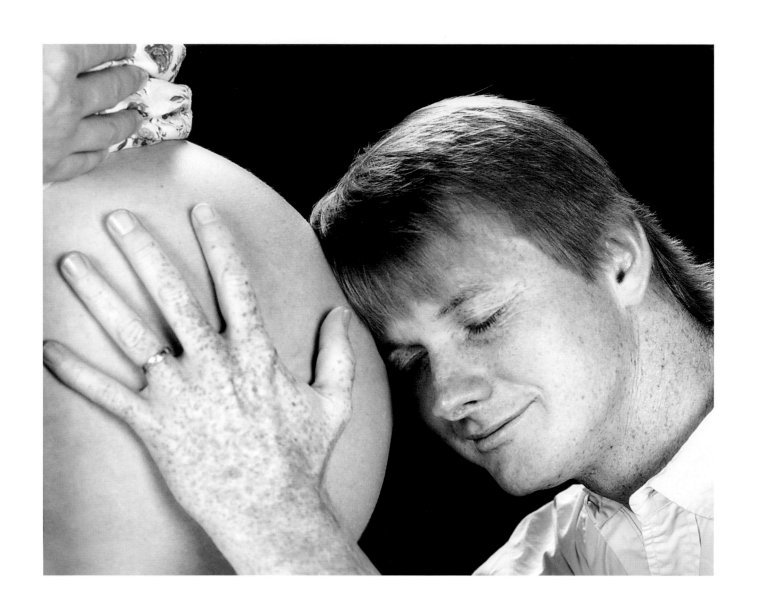

Bruce Bellcase & future son

Field Engineer

The crack of the bat, the cheers as he scores the
winning touchdown. Teachers' praises and straight A's.
"Yes, sir" and "No, but thank you anyway."
Enjoying the junior high dance. Self confidence and
determination. Respect for, and from, others.

Graduation, and then another. A great job
leads to a question. The shy girl accepts.
I am a grandpa.

I have yet to hold my son, to hear his first cry;
but I have met him, and he has grown into
quite a man.

—Bruce Bellcase

109